# Rudolf Kutzli
# CREATIVE
# FORM DRAWING

Translated by Roswitha Spence

## WORKBOOK 3
### Sections IX – XII

HAWTHORN PRESS

*Creative Form Drawing Workbook 3* © 1992 Rudolf Kutzli

Rudolf Kutzli is hereby identified as author of this work in accordance with Section 77 of the Copyright, Designs and Patent Act, 1988. He asserts and gives notice of his right under this Act.

Published by Hawthorn Press, Hawthorn House, 1 Lansdown Lane, Stroud, Gloucestershire, GL5 1BJ, UK
Tel: (01453) 757040 Fax: (01453) 751138
info@hawthornpress.com
**www.hawthornpress.com**

Cover design by Patrick Roe at Southgate Solutions, Gloucestershire
Typeset by Southgate Solutions
Printed in the UK by 4Edge Ltd
Reprinted 2006

Printed on FSC approved paper.

Printed and bound in Great Britain by
4edge Ltd, Hockley. www.4edge.co.uk

First published in Germany by Verlag die Kommenden GmbH under the title *Entfaltung schöpferischer Kräfte durch lebendiges Formenzeichnen*
This edition © Hawthorn Press 1992
Translated by Roswitha Spence and William Mann

British Library Cataloguing in Publication Data applied for

ISBN 10: 1 869 890 38 8
ISBN 13: 978-1-869890-38-4

# CONTENTS

## TRANSLATOR'S ACKNOWLEDGEMENTS

I would like especially to thank the late John Davy for his unceasing support and encouragement, my colleagues at Emerson College for their willingness to be happy 'guinea-pigs' in my early trial and error days of form drawing, the friends who have helped with corrections, typing and publishing, and my parents without whose help this translation could never have happened.

# SECTION IX

Draw a circle **1** to divide any immeasurably large surface into two areas: a "within" and a "without".

It is the ego that is active in drawing, but it is also the ego that is drawn. The form that results can be sensed, seen and experienced as an ego-form. The ego is separated from the world with a centre point enclosed in itself and self-contained, and thus the ego draws the "I" – in fact draws itself.

We saw in Section VII that drawing is both conscious deed and experience. The "I" is both the drawer and the subject of the drawing. This can indicate the relationship of the art of line to the whole human being: the ego brings the initiative, but is at the same time the form that reveals the impulse.

What do we understand or imagine by the concept "I"?

"The mere utterance of the word "I" or "self" does not as yet evoke much thought in the human being. Many epochs will have to run their course in human history before a fully conscious idea can arise in the soul when the word "I" or "self" is uttered. Nevertheless, Selfhood, Egohood can be felt in form and above all when we pass from a purely mathematical conception of form to a feeling in form; we can acquire a perception of Egohood, Selfhood in the perfect circle. If you realize this you will readily understand what follows from it. If the true, living, sentient human being, confronting a circle, senses the feeling of Egohood, Selfhood arising in the soul, or if when beholding a fragment of a circle it is felt to typify the independent self, then a learning to live in form is experienced."[1]

The form-drawer can learn to sense forms in thinking, to experience forms in feeling and to perceive forms in the doing.

Mathematical knowledge of form shows that a circle is simply a line that is equidistant from one point. But from the aspect of a feeling of form the circle appears as a mysteriously profound expression of the "self".

A little riddle by Angelus Silesius seems singularly apt:

**I know not what I am**
**I am not what I know**
**A thing and not a thing**
**A tiny speck, a ring.**

Draw a circle **1** with a "tiny speck" as its centre and try while drawing to experience the deeper meaning of Selfhood. The dynamic of a circle sometimes means that the forces from the circumference work more strongly from outside **2**, and sometimes the central forces radiate more strongly from inside **3**. This is referred to in Section VIII as Apollonian and Dionysian forces.

Circular forms work powerfully on the ego of the drawer and the observer. These forms are known as Seal forms, which have already often been discussed during the course of this work. Before moving on to the Seal forms of Rudolf Steiner, some further individual forms

could be practised. Exercise **4** shows very simply the double dynamic of forces within the circle. Five simple loops move rhythmically towards the periphery and five-pointed loops press in a counter-rhythm towards the centre.

If you vary this example you can find new motifs of your own.

The next two examples (drawn by Gudrun Hagg) are quite complicated but exceptionally beautiful compositions. Seal **5** shows a seven-fold swinging curve going twice round the circle with small rhythms moving inwards and large ones moving outwards. In Seal **6** two different movements interpenetrate each other; one is pointed, the other rounded. Compare this drawing with the callixus knot in Section VI.

After these preliminary exercises you can build a Seal form out of the art of line: the straight and curved line. Draw curved forms freely and at first quite slowly, coming out of a stratigh line **7**, and then releasing and dissolving it. The forms gradually become softer and more blurred, loosening from their starting point in waving movements until they disappear into the surroundings. This theme of "rounding" is already familiar.

Roundness indicates a dissolving, softening and loosening, and tends to arise in the centre, working its way to the periphery. Rounded forms are created by movement from the centre.

Next practise straight forms **8**. The straight lines include angles and corners. Repeated cornered forms create a crystalline quality, which contracts and mineralizes to rigid concentration. A good example is the salt solution that dries into corners, edges and surfaces. Straight and cornered forms are created by working from the periphery towards the centre.

Draw arrows that ray out from one point to work into the periphery **9**. Allow this "centrifugal" force to create forms. Rounded and expanding forms will arise which move out into the periphery. Repeat this exercise in many different ways and sense its dynamic.

Now draw arrows in the opposite direction that work from the periphery towards the centre **10**. Sharp corners and edges seem to form, directed towards the middle. The dynamic here is a contracting and hardening process, a concentration of forms. Repeat this exercise over and over again.

A question now arises: if you imagine a circle where the centre point (inner) is not in balance with the circumference (outer), what happens when the centre is stronger than the circumference? The answer is relatively simple: it stretches and gets larger. Think of blowing up balloons or soap bubbles, and draw larger and larger circles around the one centre **11**. The larger circles make the original one become smaller and smaller **12**. However, in both **11** and **12** the circle form remains the same.

In physics this kind of expansion would be called "linear". It is purely quantitative and relates to the non-living, the way a crystal grows without changing its form. Completely different laws of growth apply to a living substance such as a plant. A plant seed changes its form as it expands. A sunflower seed is not simply a miniature sunflower, but its form changes. The seed gives forth its first leaf, condenses into a stem, stretches into the next leaf and eventually gathers itself together for the bud, then unfolds into the flower and finally concentrates into the fruit. There is a rhythmical growth between the polarity of expansion and contraction to the climax – it is a metamorphosis.

The next task is to make the circle grow; the impulse should start from the centre and be "stronger" there than at the periphery **13**. However, it should not grow quantitatively but

dynamically. As has already been suggested, the force from within creates rounded forms and this includes the rhythm of swelling and pulling in, thrusting out and holding back.

The result will be that as the circle expands it will widen in rhythmical curves **14**. Practise variations of this form expansion. A regular division of the circle will bring order to these movements. Exercise **15** shows the circle divided into seven parts, creating a regulated rhythm between the alternating forces of stronger, then softer movements; the later exercise **24** can be used as a guideline. The circle therefore becomes structured in its expanding curves **15**. Note that the force is always coming from the centre, whether more or less strongly, it never comes from outside.

Exercise **16** shows a further stage in its dynamic. The waving rhythm should flow round in even curves, bounded by two circles.

Rudolf Steiner said: "it is characteristic that he who livingly enters into the feeling of form, experiences the centre stronger than the periphery, – yes, here the centre triumphs! – This is the essence of the artistic, this becoming one with the form and living within the form."[1]

Forms **14**, **15** and **16** are therefore expressions of the centre establishing itself against the periphery.

Now take the opposite tendency: the outer force should be stronger than the centre. The whole process must however be living and dynamic. Draw a circle with arrows pointing from the periphery towards the centre **17**. The effect of this impulse is a rhythm of edges and points **18**, as a force which comes from outside tends to create cornered forms.

Regulate these forms into a circle divided into seven parts **19**. Depending on the rhythm, the angles either become blunt or sharp. During practice, sense that the force comes from outside.

A further step leads to the form **20**, which is an expression of the periphery establishing itself against the centre.

The pressure from without gives the form the quality of not being a star – a star would radiate from within. Such a star would be gently rounded towards the outside **21**. The form loses its dynamic with the use of accurate straight lines **23**. The force from without, however, lends the form a quiet dynamic, a delicate tension towards the centre **22**. Practise these subtle details in many different ways, sensing the correct tension between what is too rigid or too slack.

Exercises **24** and **25** are geometrically divided circles: the five-pointed star (for those who have forgotten the wonderful construction with compass and ruler) and the seven-pointed star (for which no exact construction exists). The 4, 5, 7, 10 and 14 division of the circle can be pricked through or traced according to choice. You can also transfer them to card paper and use them endlessly as templates. The proportion of seven parts in the circle, given by Rudolf Steiner, will be more thoroughly dealt with in the next section.

Trace the large circle **24** and the ¾ circle, as well as the 7 and 14 radii, then draw a star freehand by joining each fourth point (jumping 3 of the 14 points on the circumference each time) to form a structure. Now draw a rounded line in regular but dynamic curves so that the outer movement exactly touches the ¾ circle and the inner part lies against the sides of the star **26**.

Watch out for the following possible mistakes: in **27** the outer curves are too extended and

one-sided and the inner form (arrow) is lost; in **28** straight lines (arrow) have appeared where curves should be; in **29** pay attention to the "turning" part of the curve, sensing that the force comes from within; in **30** whether it is a strong force or gentle impulse, it radiates from the centre and not in an outside/inside way, as is the case with the wave.

Note that the original circle has more or less disappeared. The larger circle surrounding the whole **26** merely marks out the space or "arena" in which the movement of the line can occur.

In drawing the angles, possible mistakes may occur **32, 33, 34, 35** and **36**; pay special attention to the pointedness and exactness.

What would occur if the two forms **26** and **31**, each developed from polar opposite transformations of the circle, came together to create one form? Four variations are possible: **37, 38, 39** and **40** – which of these are the best and most beautiful?

At first glance they all appear to be the same. However, when you look more closely and actively enter into each Seal form, great contrasts of quality become apparent.

In the first two examples **37** and **38** the outer force appears to press heavily downwards; the point of the apparent star also faces downwards. These two forms may seem unharmonious.

The second two examples **39** and **40** create a more harmonious effect. In **39** the resultant form of the inner force alternates with that of the outer force. The rhythm is lively and delicate (angle to centre, curve to periphery). The last Seal **40** shows a union where both forces come together, each moving simultaneously towards the centre and the periphery, while at the same time each holds its force in abeyance. The togetherness, not alternation, of this rhythm gives the whole form an archetypal quiet and enclosed quality.

The last form **41** is the first of five forms that Rudolf Steiner created in 1907, presented in the programme leaflets for the congress of the Theosophical Society in Munich.[2] With these forms Rudolf Steiner created the foundations of a whole new art of line, which we will go into more deeply later. In the earlier sections of this work of "Ars Liniandi" forms of the past were researched as pointers toward developing new capacities for understanding, but Rudolf Steiner's forms take us directly into the future. "The seals are pure forms, just as there are pure thoughts."[3]

It is important that this first seal was not "just drawn". It arose out of the two creative and archetypal principles: the round and the straight. The process did not arise from any preconceived thoughts, imaginations or indications. It grew purely out of living sensitivity to form and the feeling for its language. No symbolic, allegorical or nature forms were allowed to be guiding factors. We arrived at an artistic form that unfolded our creative forces and enabled quite new experiences to speak to us. "Art is the vehicle through which the Gods can speak to man."[4]

Once this seal has been discovered, experienced and practised we must proportion it as Rudolf Steiner indicated **41**. This should not be a matter of belief, but a hypothesis of research followed by any number of other proportions. Test it for yourself and you will discover just how "true" this form is the way Rudolf Steiner fashioned it.

Drawing **41** is the bringing together of **26** and **31**, with the addition of the little seven-pointed star in the centre that appeared in **31**. Cover the centre star with a piece of paper and you will see how the whole design loses its balance: the outer force (angled form) overpowers the inner force (rounded form). The radiating quality of the little star brings about an

equilibrium.

Rudolf Steiner called this form the Saturn Seal. It could perhaps also have another name, relating to the whole process of its becoming.

With the quotations of Brunnelleschi and Kepler in mind (Section I), we can observe how the seal is born of the two basic gestures of straight and round, of binding and releasing. These two fundamental elements were applied to the geometric circle in a living and dynamic way. The circle is in a sense an all-encompassing image beyond time and space, a condition before creation that becomes form, speaking to us as we draw it. Perhaps it could be referred to as an "Origin of Worlds".

Repeated drawing of this form combined with attentive observation make it possible to sense that this discussion is not hypothetical, but relevant. There is a majestic restfulness in the forms in their whole gesture and line. Its simplicity is profound.

You can experiment and draw the whole seal much larger and with different pencils or brushes or create it from different media. However, our task here is to stay with the art of line, leaving other factors to play a secondary role.

In Rudolf Steiner's book *Occult Science, an Outline*[5] he uses the term of "Old Saturn" to describe the origin of worlds. This is the reason why this seal is called the "Saturn Seal".

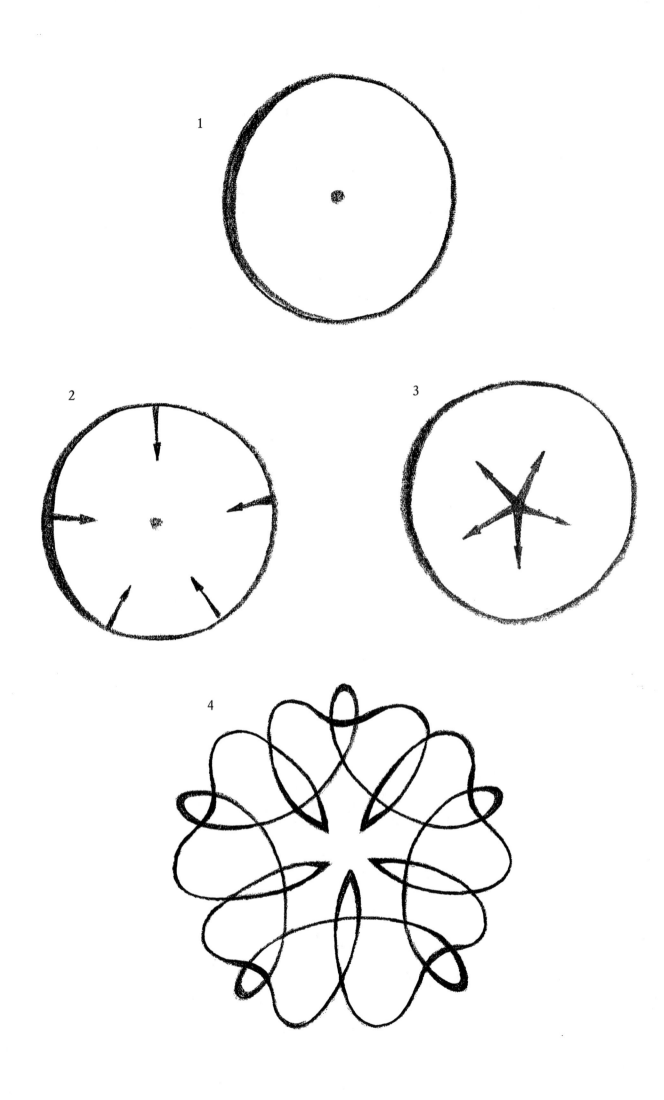

5

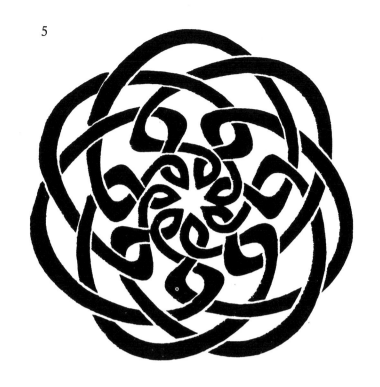

6

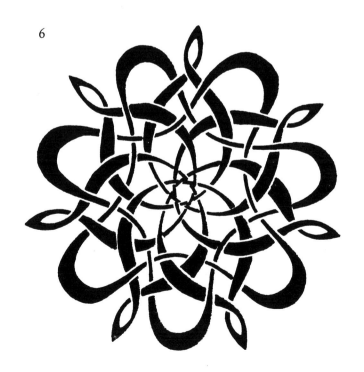

9

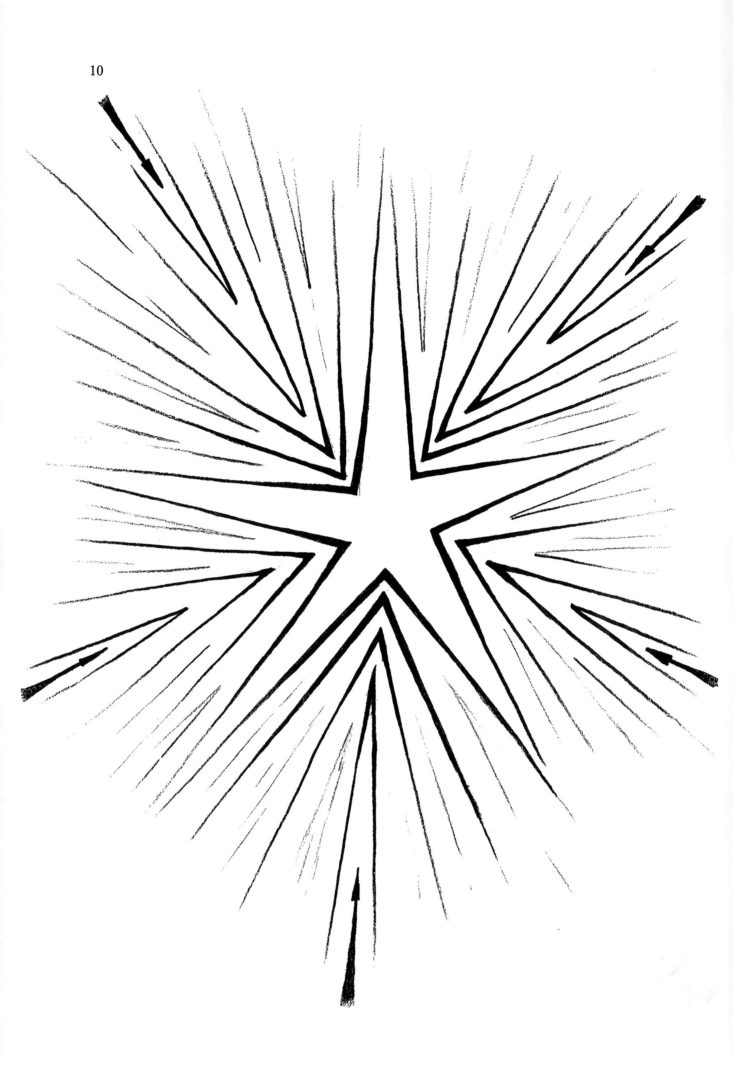

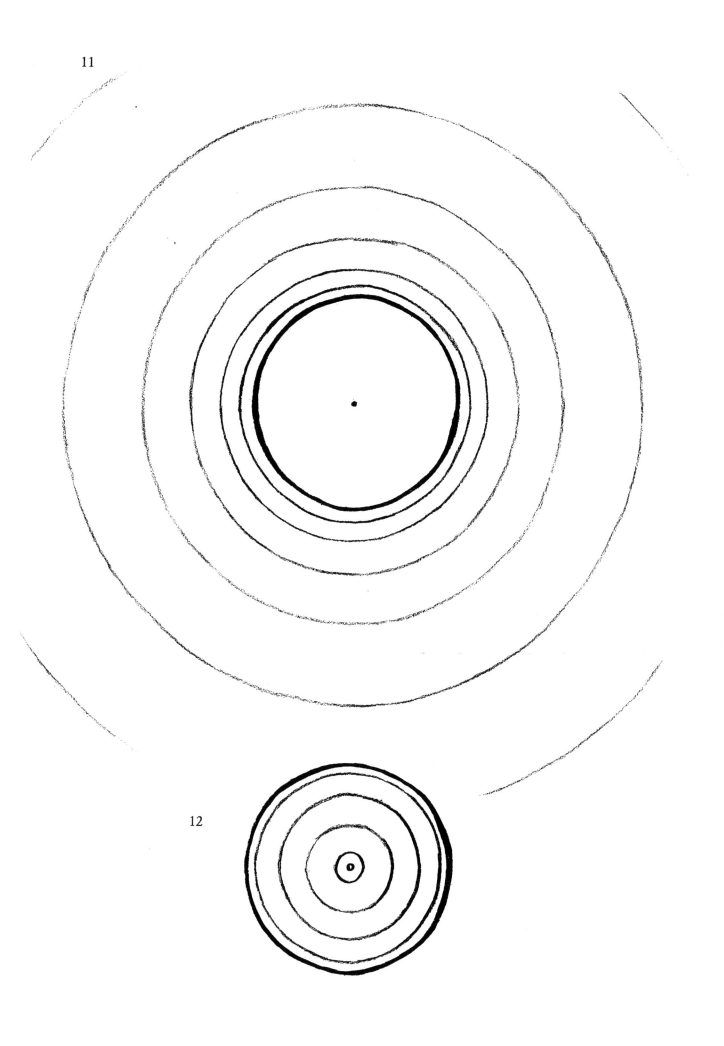

11

12

13

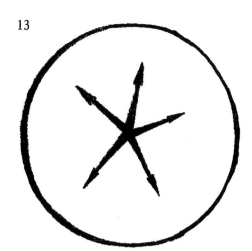

14

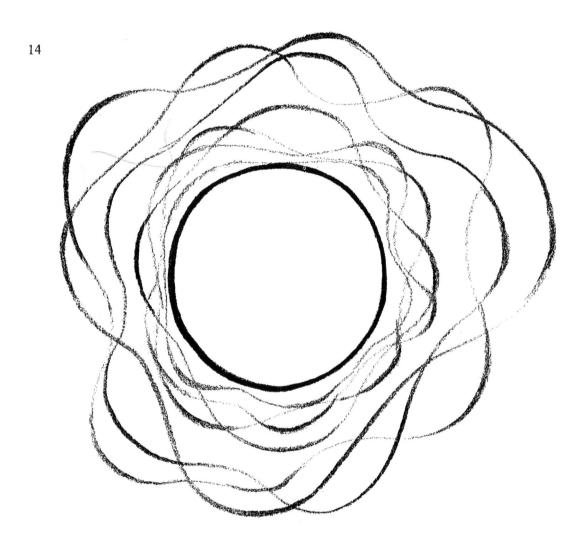

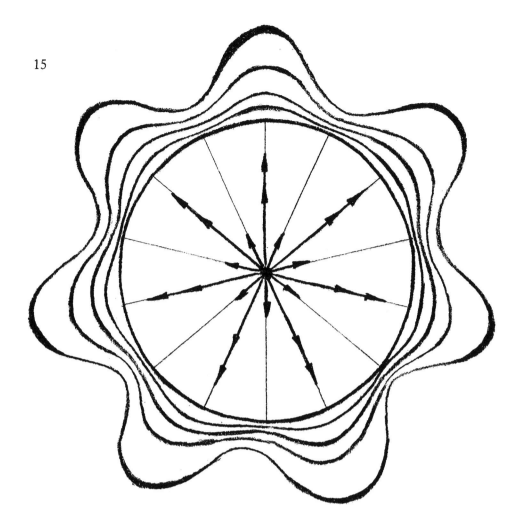

15

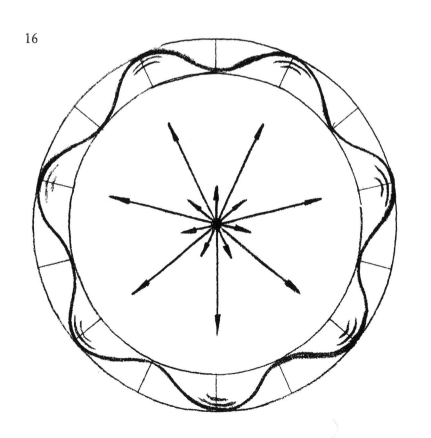

16

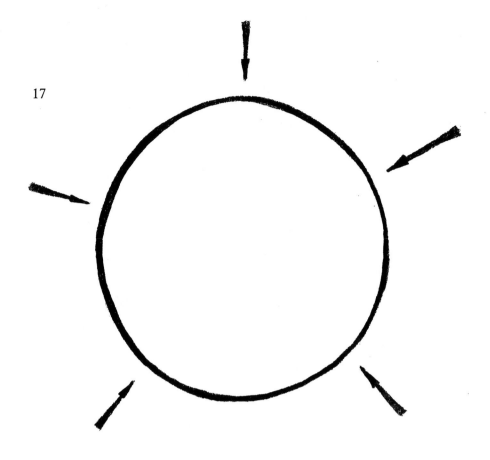

17

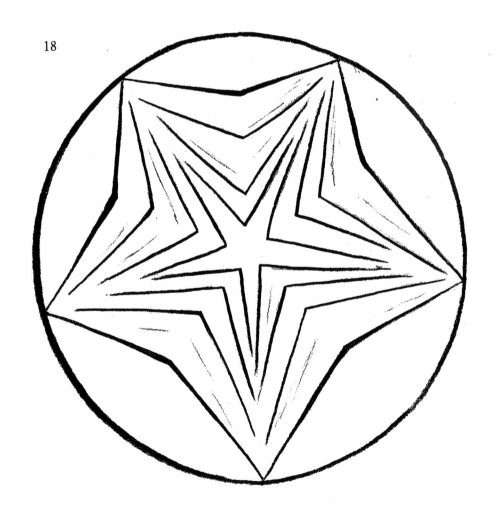

18

19

20

**21**

**22**

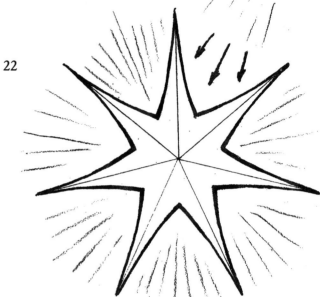

**23**

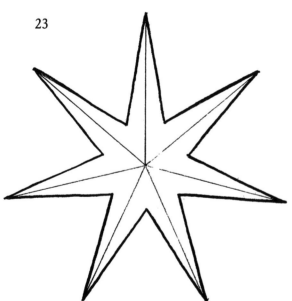

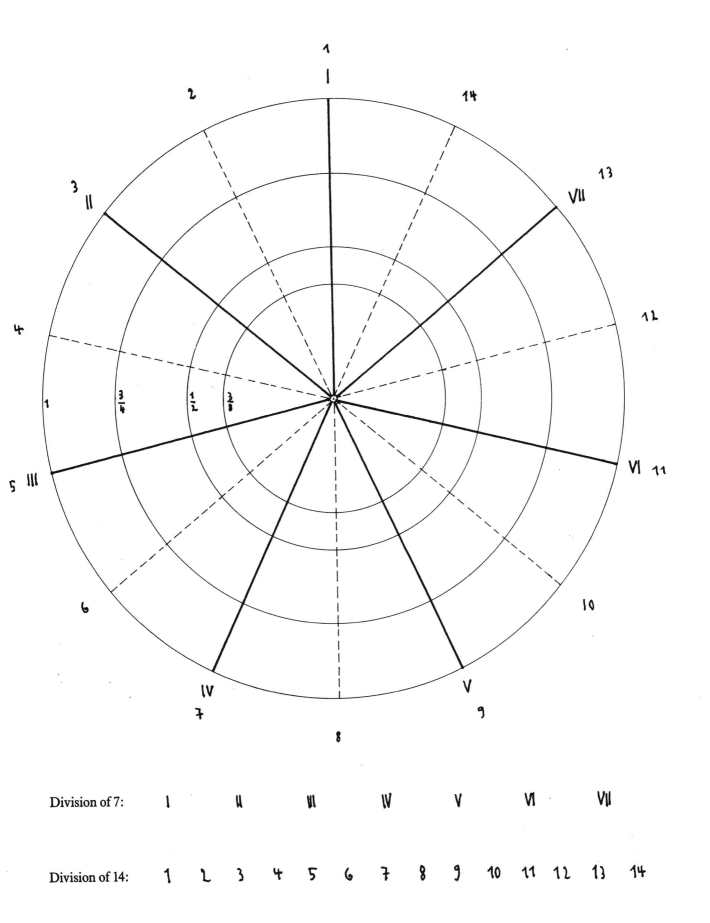

Division of 7:      I        II        III        IV        V        VI        VII

Division of 14:    1    2    3    4    5    6    7    8    9    10   11   12   13   14

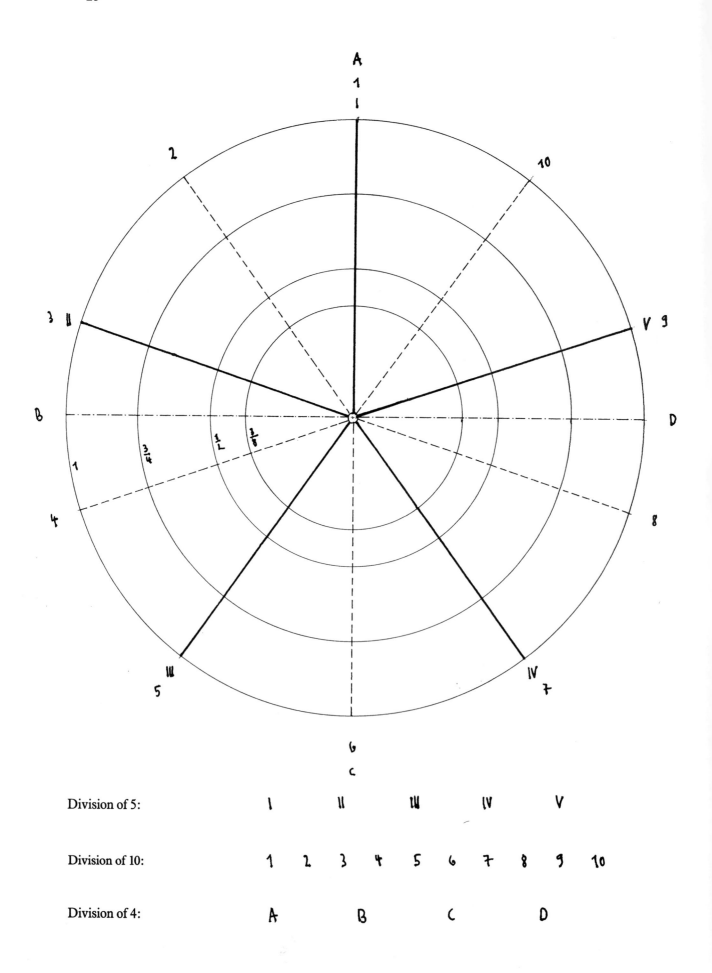

Division of 5:　　　　I　　　II　　　III　　　IV　　　V

Division of 10:　　　1　2　3　4　5　6　7　8　9　10

Division of 4:　　　　A　　　B　　　C　　　D

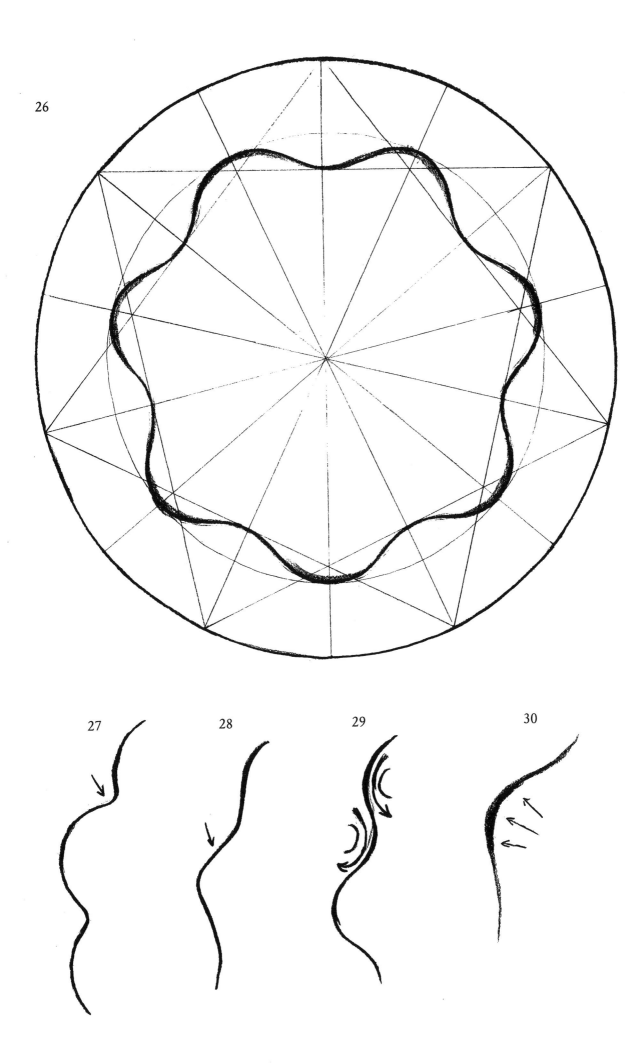

26

27 28 29 30

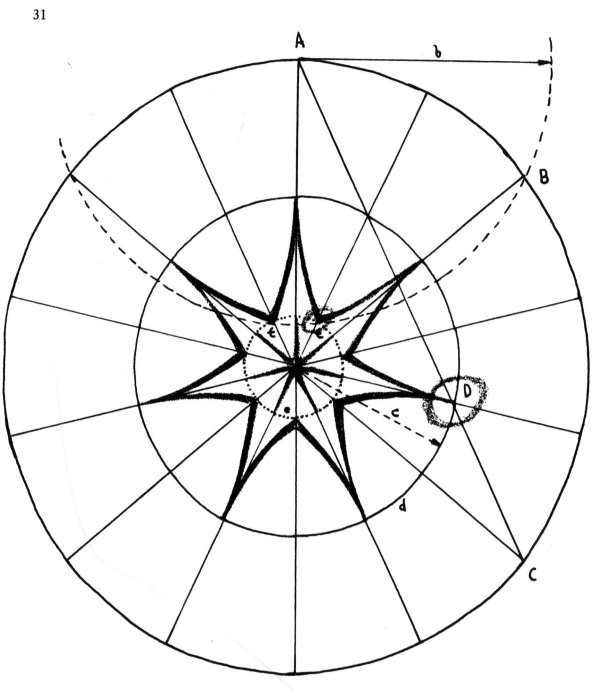

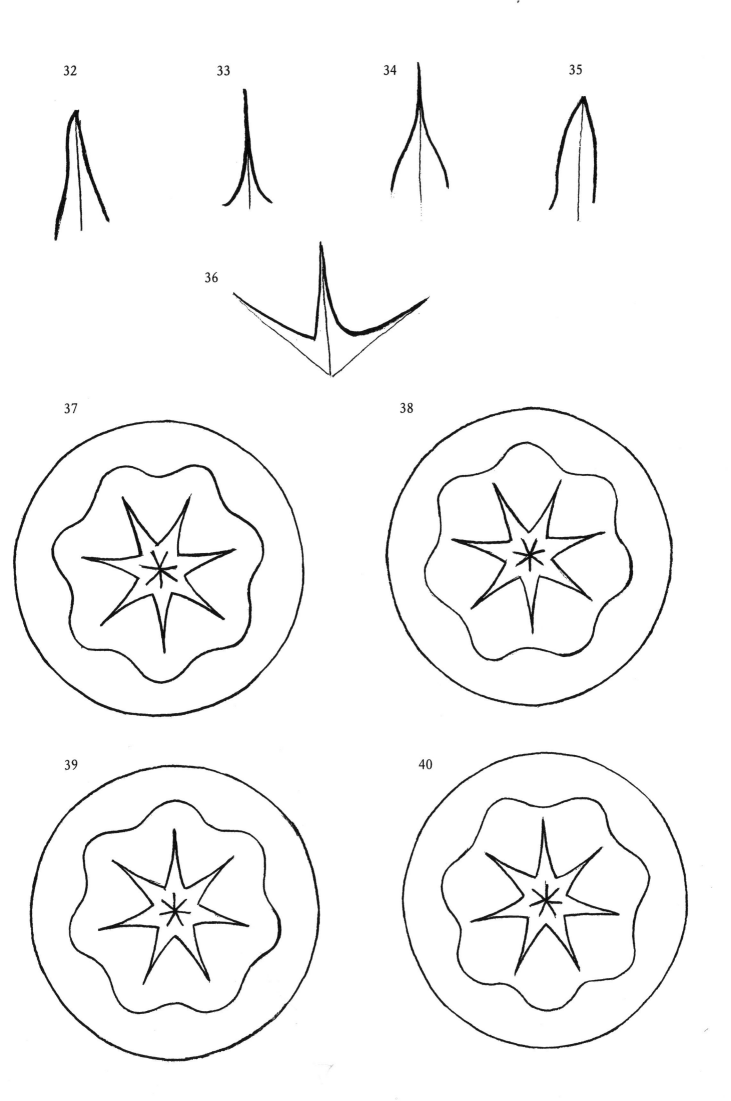

32    33    34    35

36

37    38

39    40

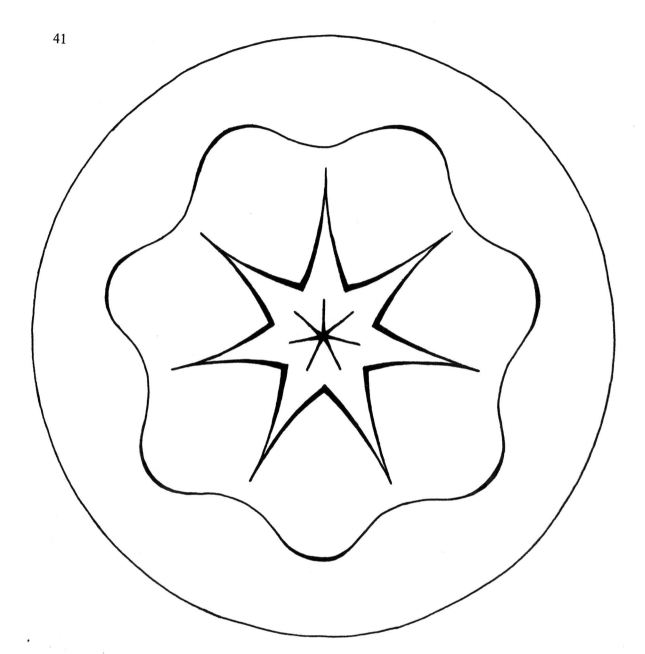

# SECTION X

Section IX ended with the Saturn Seal. After repeated studying and drawing of this form you may have sensed a certain static quality within its restfulness, which could impel you to develop the form further and release it from its onesidedness. The following sections consider this task.

Drawings **1, 2** and **3** are exclamations, the sharper the angle towards the point, the more aggressive they are. If we transform the sharp angle to roundness our experience of it changes. Instead of detaching itself from the dot it seems to turn towards it in concentration and interest **4**. In **5** this gesture becomes sympathetic instead of a mere statement and in **6** it even opens to allow the essence of the point to stream in.

Now draw these harmonious transitions quite freely in a circle **7**. It could give us a sense of how the periphery is filled with interest and concentration for what lives in the centre, rather than indicating just a statement of fact.

When transforming a straight line into a curve **8** it opens itself to what may flow in (indicated by the arrow), and becomes a parabola. The familiar form **9** where the point presses upward to create a curve is reversed in the parabola, in a receptive gesture **10**. Drawing **11** illustrates this freely within the circle. This new form could suggest to us that inwardness surrenders itself to forces which stream from outside.

These two themes can now be combined to create a new seal.

Exercise **12** shows possible proportions of the circle divided into seven parts. The central forms have their curves against the half-sized circle with their points aiming directly towards the middle, without actually touching it. The centre space stays free. The curves of the outer forms are not set on the halfway circle, but slightly further inwards at K. If this were not so, the whole seal would disintegrate. The branches of each form are not cut off by the outer circle, but have a tendency to reach towards infinity E, F. Pay attention to the symmetry S and at G sense the space more than the actual line, like a "sounding" interval. The characteristic broadening of the line gives it an unusual dynamic.

At the bottom of the page various mistakes are indicated: take special care that the inner forms are pointing to the centre - not touching, but leaving it free **13**. The extended points must not cross each other as in **14**, nor must the curve become static as at **15**. The outer forms must not be too rounded or too straightened **16** and **17**.

Exercise **18** is the seal as Rudolf Steiner drew it. From the "world beginning" of the first seal something utterly new is born. By completely turning inside out the two opposite "statements of self", a form arises whose language can be grasped by individual will. It could be seen as "that which is born out of the periphery, the cosmic enlightened wisdom is reflected in the centre as radiating warmth and power of love, to which the periphery responds in harmonious equilibrium."

This seal was created by Rudolf Steiner for the cover of the book of his first Mystery Play, *The Portal of Initiation*. Its form language guides us from "resting in self" to the threshold of a whole new world. The seal is like the essence and distillation of the entire play.

The connection of the form to the content of the play must not be taken literally. Rudolf

Steiner did not create the seal to reveal all the secrets of the drama at first glance, but it came from the artistic medium of drawing itself. The seal speaks purely through the language of its form. When drawing it, with all the preliminary exercises, we engage in the Michaelic "movement of the will",[1] which awakens in us forces and abilities that enable us to understand the drama in quite a new way.

Specific colours are suggested for this form: a shining red for the lines on a background of a deep dull violet red **48**. *The Portal of Initiation* was conceived as a Rosicrucian Mystery Play and the design incorporates the first letters of each of the Rosicrucian words:

**Ex Deo Nascimur** – From God we are born
**In Christo Morimur** – In Christ we die
**Per Spiritum Sanctum Reviviscimus** – Through the Holy Spirit we are resurrected.

The reproduction of the seal shown here is as it was originally intended, but the design on the bookcover of the first edition of the play appeared slightly tilted. It was asked whether this was correct: "showing a weightlessness that could indicate how the earth and its inner connection to the heavens relates to the Cosmic All." All Rudolf Steiner's seals have this intrinsic quality, without the need to be tilted.

The gesture of the form was transformed from "the statement of the centre – the statement of the periphery", towards "the inner form streams outwards, the outer form streams inwards".

Now try a further sequence of transitions: draw a dot, and towards it a straight line **19**. Does the line get closer **20**, as though to observe the dot, or attach it? It does neither, but reaches around **21** and encompasses it **22**. A "sensing" or "questing" gesture arises. The question mark has this form. Draw several such question forms radiating out from the centre **23** and **24**. They are no longer making a statement, but rather an inner questing towards the outer.

Next draw two double spirals that reach to left and right, gathering a kind of strength in the middle **25**. These designs bear a similarity to ancient symbols of the exalted Godhead, primeval Motherhood, the Giver of Life, etc. **27** and **28** come from Brittany, 3rd century BC. **29** comes from Ireland 2nd century BC. **30** comes from Val Camonica, 2nd century BC, and **31** from Spain, 2nd century BC.

Let the middle of the curve drop down into a point **26**. A form appears that has an archetypal majesty, as though gathering cosmic creative forces and bringing them downwards. It is similar to the zodiac sign of Aries the Ram **32**.

Place two similar forms in counter direction **33**, "the forces from above and below are engaged in a battle". The points face each other at a distance, whereas the arms reach into each other **34**.

Emphasize this movement **35**: "a mighty power reveals itself from above and from below the movement glances upwards in comprehending activity".

Vary the motif in different proportions. It is the main motif of the following seal in which the centre form is a five-pointed star, a pentagram **36**.

In Section V, exercises **74** to **97** we worked with the pentagram and spoke of its higher ego-force as "the sign of Michael". Rudolf Steiner describes the pentagram in the following

way: "ultimately, all that the cosmos has carried through and what exists as Mankind is symbolized by the pentagram – it reveals to us the star of evolving humanity. It is the star, the symbol of the human being that the wise Kings followed just as in ancient times the wise priests did. It is the essence of the earth, the great Sun Hero, He who is born in the Christmas Night, as the loftiest Light that shines forth out of the darkness.[2]

This sign (the pentagram) coming from the cosmic periphery has penetrated the very centre **36**. The motifs are placed five times around the star as though sensing the star's radiance and turning outwards, almost in a question, to which the outer motifs respond in majestic strength. The outer spirals "give" to the inner spirals, which receive in understanding.

The proportions are quite concretely measured out of the five divisions of the circle **36**. Draw the pentagram into the large circle: S J U V W. The inner pentagon gives the size for the centre pentagram. The curves at the base of the middle motifs rest on the outer sides of the centre pentagon. Point H is found where the half-size circle crosses the five radii Z J. The lower point is found at the intersection of the inverted pentagram O R Q B A.

To find the centre points of the spirals draw a parallel line C D to A B through the point at E (arrow). The middle of the spiral D lies on the parallel line where it intersects with the extended line of the centre star. The middle point of the outer motif F lies on the radius where it intersects with the connecting line between spirals G and D.

This is an approximate basis on which to build the form.

Become familiar with this seal by drawing it over and over again, becoming freer and freer **37**.

The language of this form is powerful: the searching questioning of the inner towards the outer; the outer unfolding movements; the coming together in conversation of inner question to outer answer and outer question to inner answer, all culminate in the central shining star. New "awakeness" and courage are born and a will to face what is to come.

This seal was designed by Rudolf Steiner in 1910 for the second Mystery Play, *The Soul's Probation*, in a glowing yellow on a deep red background **49**. Once again, the essence of the whole play is portrayed in the form.

If you try to turn this seal upside down you will find it is not possible because the outer form above in the centre becomes too influential and the centre pentagram does not sit well on its point.

Now you become aware of a further transition: in this seal the centre star shines quietly. This radiating force could set the whole circle into an activity of movement.

Practise again the simple wave **38** and **39** (as in Section I) and bring it to an ever stronger movement **40** and **41**.

In Section IX, exercise **16**, the wave was brought into a circle. Now bring the above form into a circle and it will rotate **42** in a clockwise direction when set in motion from within.

The same form turns in the opposite direction when set in motion from outside **43**. Drawing **44** is more a question of which way it is turning.

This newly arisen form relates to an ancient Sun symbol, the "swastika". One often hears it said that turned one way it is "good", and turned the other "evil". Comparing all the signs **45**, whether turned from centre or periphery, it is hard to come to any decisive conclusion.

The seal that Rudolf Steiner drew in 1912, **46**, quite clearly turns from within in a

clockwise direction. It is built into a circle divided into eight sections. Draw three circles of radii 3cm, 6cm, and 9cm. Now divide the circle into 8 sections or trace the given example. The diagonal crossing at the centre comes into a rotating movement. Follow the dotted curve from the centre to O. The lines of the cross lie along the curve and go through the intersection of the smallest circle with radius B. The spiralling impulse is further enhanced by the second form E to F that lies along the dotted curve from K to G. It is not easy to achieve the double curvature of this form, or its little conclusion at G, – four times too!

Everything would be scattered if not for the vortex movement of the circumference "guarding" its content. This "guardian" form is closed in on itself but extremely dynamic. It is able to meet a resistance and then swing free in renewed strength four times.

Your feeling for form should allow you to perceive the powerful quality of this seal **47**.

The sign of the cross (of death) in the centre becomes active, creating unwinding spirals that can renew and enthuse the drawer and observer. The whole form would disintegrate at a certain point if it were not for the strength of the enclosing periphery. This too rotates in a rhythmic way, but is contained by a counter force. The seal does not allow us to rest, but urges us to awaken to courage and attention.

Rudolf Steiner created this seal for the book cover of his third Mystery Play *The Guardian of the Threshold*, in ochre yellow on a cool blue background **50**.

The seal that Rudolf Steiner created in 1913 for the fourth Mystery Play, *The Soul's Awakening* is not in fact a question of form drawing. It is included to show it in its colours **51**. The form has become quite simple: an inner and an outer circle in pale blue on a peach coloured background. The outer circle is shaped like a snake that bites its own tail. Ancient occult symbols fill the space in powerful self-knowledge. Twelve letters form the words:

**Ich Erkennet Sich** – The I knows itself.

This theme will be developed further in the next section. We will then proceed to the bases of the pillars of the first Goetheanum, finishing with Rudolf Steiner's planetary seals.

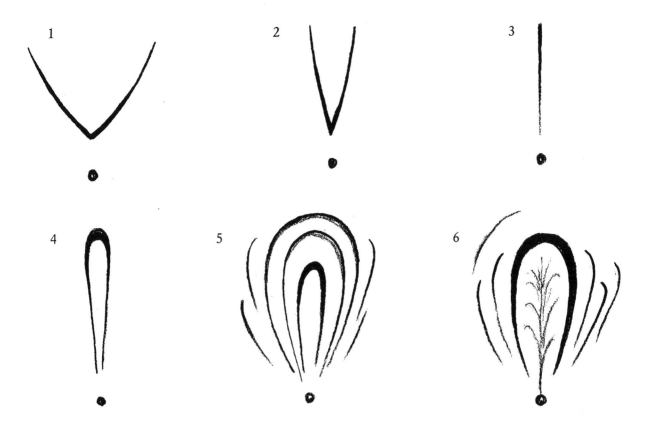

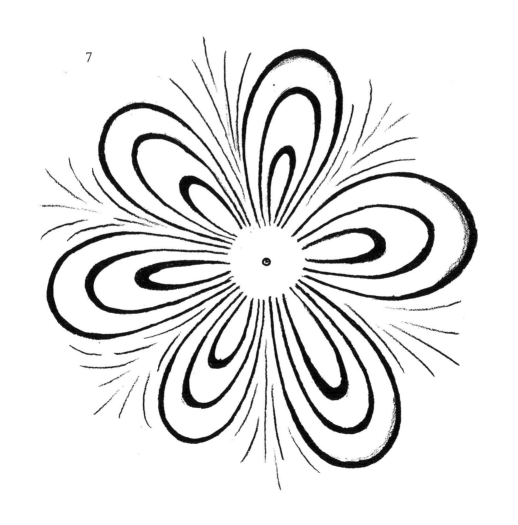

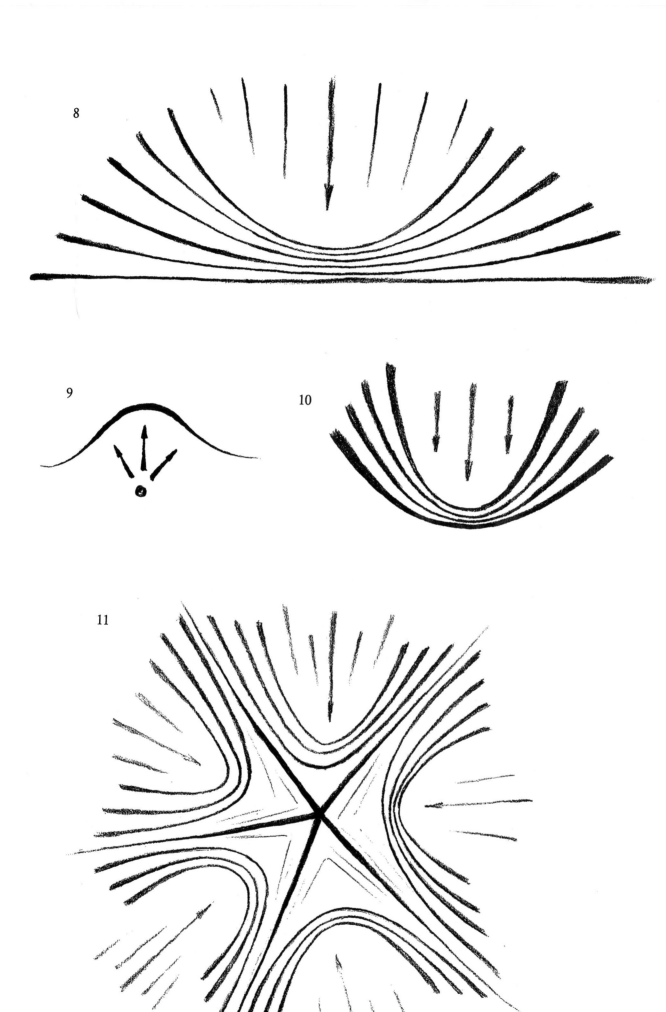

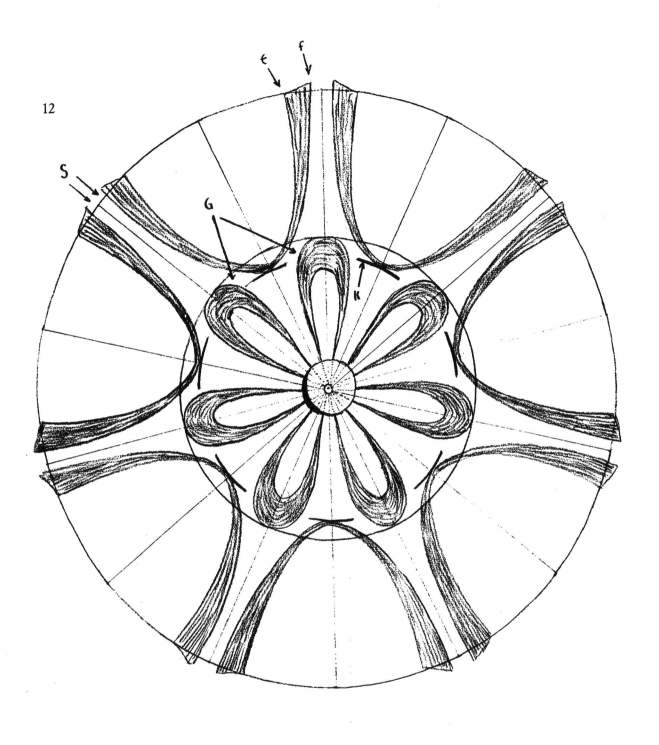

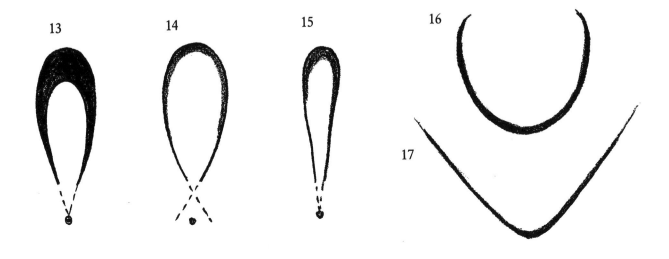

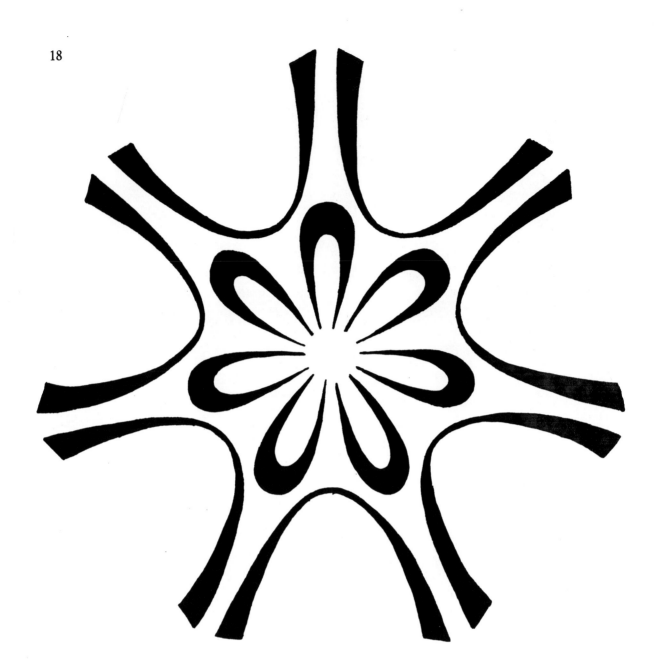

19    20    21    22

23

24

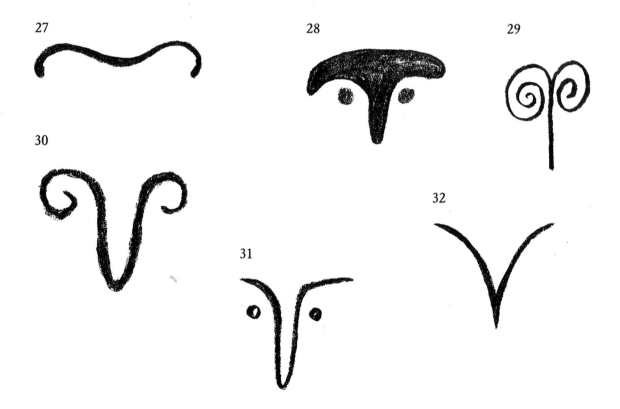

33

34

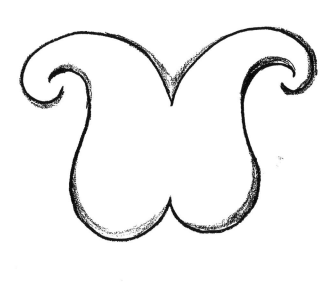

35

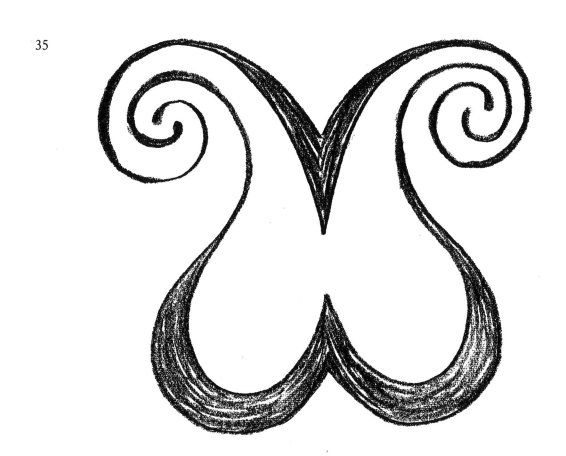

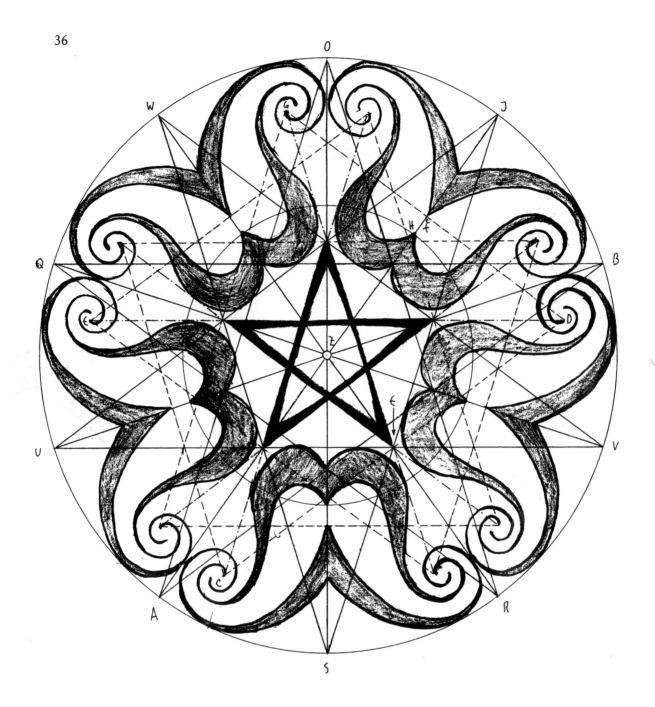

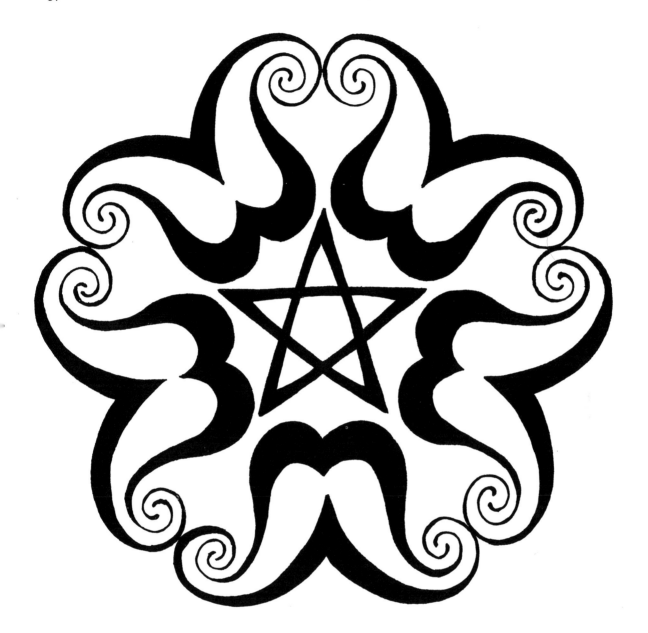

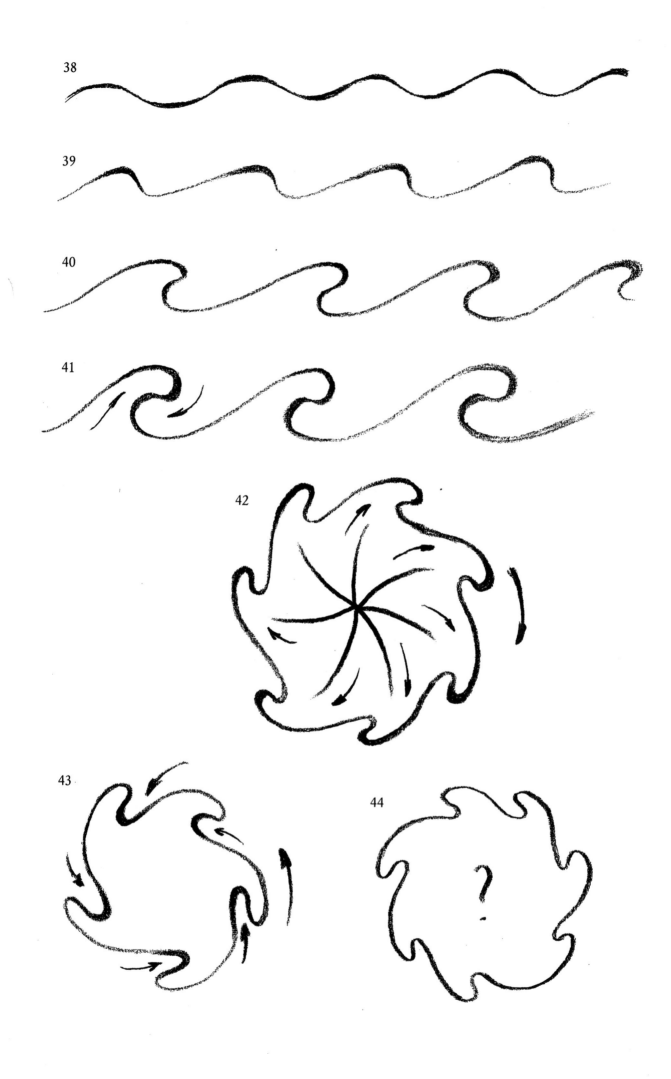

Val Camonica
1800 BC

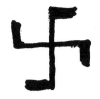

Corinthian
100 BC

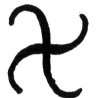

Mykenos
1300 BC

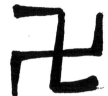

Early Christian
200 AD

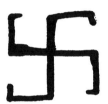

Boeotian
500 BC

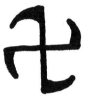

Early Christian
200 AD

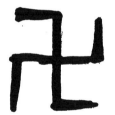

Attician
400 BC

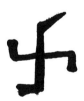

Stone Masonry
Cologne 1200 AD

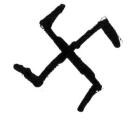

Paestum
600 BC

Bogomilian Sign
1400 AD

1933

Druid Stone sketch
by Rudolf Steiner for
3rd Mystery Play Seal

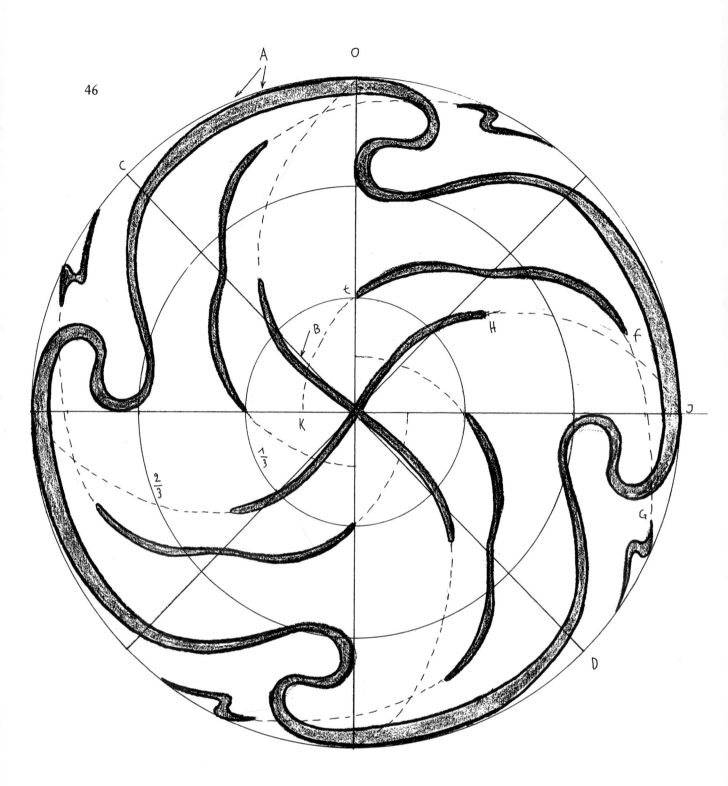

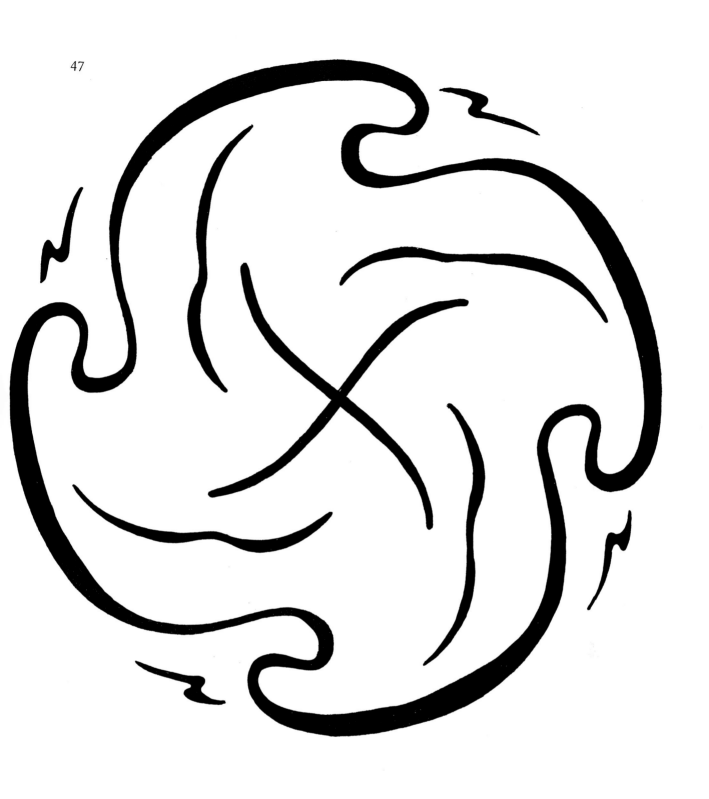

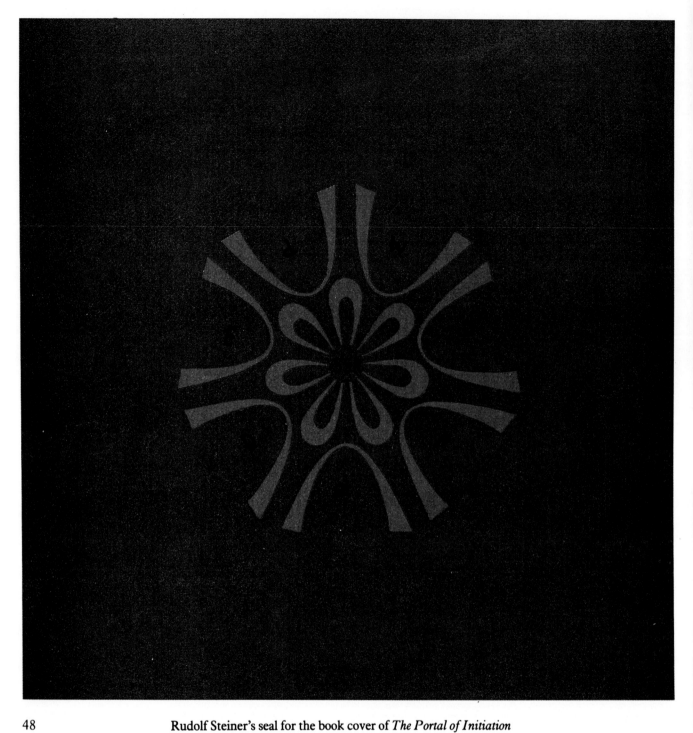

48      Rudolf Steiner's seal for the book cover of *The Portal of Initiation*

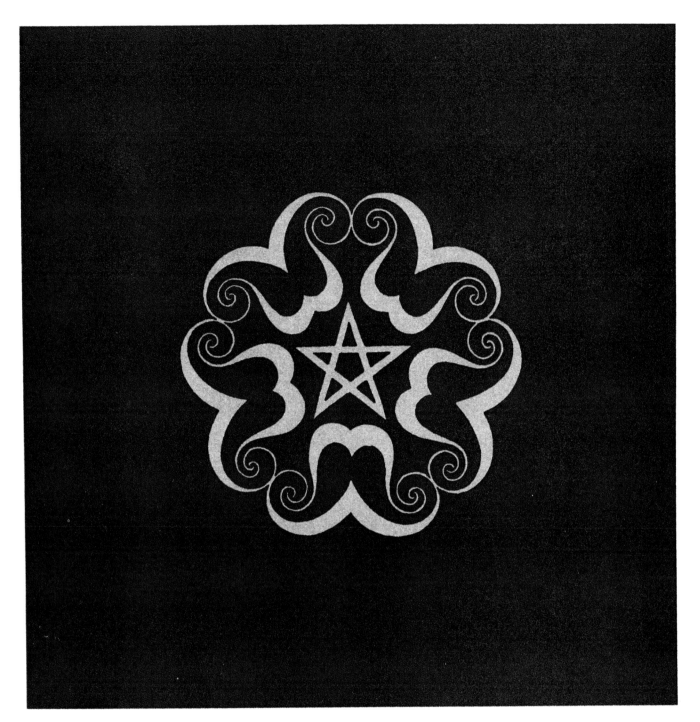

49        Rudolf Steiner's seal for the book cover of *The Soul's Probation*

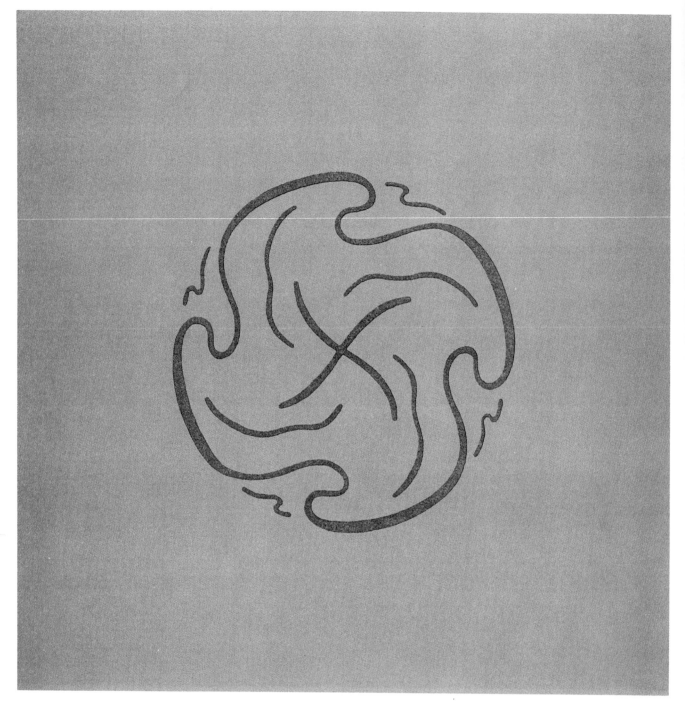

50                    Rudolf Steiner's seal for the book cover of *The Guardian of the Threshold*

51                    Rudolf Steiner's seal for the book cover of *The Soul's Awakening*

# SECTION XI

*Dedicated to Carl Kemper 1881-1957, in gratitude.*

In the preceding sections a seal form was developed out of the fundamental elements of the straight and the round, the inner and the outer. Rudolf Steiner designed and published it in 1907 under the name of the "Saturn Seal". The process of building the form did not involve any random ideas or false mysticism; it arose purely out of relevant artistic features. This method reflects Rudolf Steiner's approach to the artistic and creative process.

The planetary seal forms that Rudolf Steiner created in 1907 preceded the planetary capital forms of the pillars in the first Goetheanum, built in 1914.[1] Briefly, the line forms gave rise to sculptural forms in several steps: in 1909 they appeared in the "Modellbau" in Malsch; in 1911 they were carved in red sandstone for a meeting room in Stuttgart; in 1914 they were carved in wood for the first Goetheanum in Dornach, Switzerland.

It remains an open question as to why the circle for the seals is divided into seven parts. Geometrical calculations with ruler and compass enable us to divide a circle into regular parts from 2 to 6 (and their multiple numbers). These result in interesting measurements which have no common calculation and often include "irrational" numbers difficult to grasp with one's understanding . (Irrational numbers are an unlimited number of digits after the decimal point which have no regular pattern.) For example in the regular quartering of a circle the diagonal of the resultant square is $1:\sqrt{2}$. This root is irrational, to put it naively, it is not a number but a measurement. If we divide a circle into two it relates to "pi"; divide it into three or six and the measurement is $\sqrt{3}$. If we divide it into five the impossible-to-calculate measure of the "Golden Mean" occurs. All these measurements are beautiful in their proportions and are to be found in many varied examples of minerals and nature; they could also be referred to as beautiful proportions in space.

The division of a circle into seven can bring us new experiences and perceptions. Number seven seems to relate more to time than to space. What happens in time often occurs noticeably in seven characteristic stages. The week has seven days; the human biography can be seen as having seven distinct phases. A process in time is shown for example in exercise **46** Section I where the geometric form changes in seven consequent steps.

The usual "spatial" method of calculation with compass and ruler is of no help with the construction of the seven-sided form, it is just as possible to create it out of movement.[2] Because of this it is particularly suitable for the seals, which have the tendency for transformation and especially for a sequence of metamorphosis. To assist an inexperienced drawer to a regular sevenfold circle division, exercise **1** can be traced, pricked through or copied for a template out of cardboard.

To draw these seal forms, however, Carl Kemper recommends us to practise seven-pointed stars freehand: "drawing seven-pointed forms is enlivening, triangles and squares interwoven, continually jumping one or two points, or as radii, symmetry, lines curved inwards or outwards".[1]

49

The following exercises are some examples: **2** is a seven-sided form, **8** a "blunt" star, **14** a "sharp" pointed star, and **20** a radius "radiating" star. Draw the forms larger, drawing all the connecting lines by hand even if you use a template for the main shape. There are variations of each basic motif: **2 – 7, 8 – 13, 14 – 19**. Other variations are possible, but they are all always enclosed, symmetrical, and of a continuous line. **23, 24** and **25** are asymmetrical forms. Some people will find it interesting to calculate the variables. Others, such as practising formdrawers, find it enlivening to enter into the element of "play".

Instead of using straight lines these exercises can also be drawn with curved lines. An exceptionally beautiful form which moves in a harmonious and musical way appears in Carl Kemper's book *Der Bau.* (See page 60.) It is quite difficult to grasp but can be built up out of the exercises already practised in these books. This series of exercises is a wonderful artistic preparation for the drawing of the seal forms. Leaving aside any preconceived ideas we learn to combine hand and eye in a living way following the inner dynamic of the line.

"One may understand (the seal) in that movement when the eye follows every twist and curve, where the eye of the soul is able to follow the physical eye, where one is not concerned with the name of Saturn – Sun – or Mercury column etc. but where the forms themselves are followed, how one grows out of the other, how everything lives and weaves, where all false mysticism falls away and where the human being really makes an effort to 'go with' these forms".[3]

As a starting point draw two well-known and practised forms: a three-looped knot **26** and a lemniscate **27**. Now bring the two forms together in such a way that they interweave and move harmoniously with each other **28**. Then draw a seven-sided form as a structure and then place the two forms inside it in a balanced way **29**.

A new impulse of movement takes place in step four **30**. A force presses towards the centre from above and from below. This causes points to develop in the lemniscate above and the knot curve below. The lower curve of the lemniscate is also bent inwards. Whilst freely drawing this "play" of forms take special care that the law of the structure, the seven-sided figure, is not lost. In step five the points above and below move further into the loops **31** and the indentation in the lower lemniscate curve is deepened. The further this deepening goes the nearer it comes to the lower curve of the threefold knot until they flow into one another and become a new diagonal crossing as the sixth step **32**. It has become one line moving in a dynamic way through and around the seven-sided form.

In the seventh and final step **33** the form reaches its expressive conclusion. The two small loops refine its rhythm, particularly the upper loop, where the whole form culminates and comes to rest.

This form swings and moves rhythmically, binding and releasing in the dynamic law of the seven-sided figure. Repeated drawing of this form, sometimes small and at others large, with fully awake and attentive sensing of the inner and outer movements, can become an exercise of meditation as well as an experience of the creative healing forces. Drawing **34** is only half the form, but it highlights the musical aspect, almost enabling one to "hear" the force of its "word". This form has been named the "Butterfly" form.

Now follows a preliminary exercise to the "base seal" (the seal that relates to the form at the base of the pillars under the larger cupola in the auditorium of the first Goetheanum, Switzerland). The way the circle form relates to the cosmic weightlessness or hovering

quality **35** has been mentioned many times before. If it had weight or levity forces, pulling the form down **36** or letting it float away **37**, the circles would shape themselves into drops.

Bring a gentle but decisive pressure towards the circle from above. The forces of resistance create a boundary from below. Through this the circle changes its shape. The result is a simple indentation above and the carrying force below in a curvature, like the prow of a ship **38**. This is the line drawing of the base of the first pillar. It could not easily be a motif of a capital. **39** shows the approximate proportions of the whole form. At P, S and at the bottom the form should have clear corners. Each pillar base will be studied before progressing to the seal motifs.

The second base shows a new motif. This change should be seen as a metamorphosis of the first. **40** and **41** show both bases together. What is the law of this transformation?

Two leaflike forms unfold from being enclosed. It is essential at this stage to avoid all systematic changes which would follow a continuous stepwise process. True metamorphosis means the first form has to, as it were, dissolve into a nothingness before it can gather its creative forces anew to rise up again into a new form – a kind of "death and resurrection". Goethe, the master of metamorphosis, sums it up in his little poem "Selige Sehnsucht" (ensouled yearnings);

**As long as thou hast it not**
**This dying and new becoming,**
**Then art thou but a dull guest**
**Upon this dark earth.**

There are two levels of formative forces: one level is that which "has become", the fixed form or "picture", the "finished work". On a higher level is the sphere of "becoming", the process of the formative forces and their effectiveness. The creation of the one is sense-perceptible, the effect of the other is supersensible.

This process of transformation – the dying and new becoming – can be examined step-by-step **40** and **41**.

A mighty force A descends from above whilst the lower form hovers and melts into the base. Simultaneously another force B rises up from below and creates the two leaflike forms. And at the sides forces are also at work bearing down into a curve and upwards into a point. Try to follow this metamorphosis inwardly, not in a rigid, formal way, but dynamically in movement. This is not easy as it requires a step into another level of consciousness for which everyday thinking is inadequate.

The first Goetheanum is a great help here, (it was destroyed by fire on New Year's Eve 1922/23). **42** is the ground plan of the two cupolas. The western and larger space was the auditorium over which rose a great dome. This rested on two rows of columns. The sequence of forms of the pillars' capitals and bases led the eyes of the audience towards the east, the smaller space of the stage. Above the capitals was a carved architrave and the ceiling of the cupola was painted. Coloured light entered the space through stained glass windows. The great wood carving of the representative of Man between Lucifer and Ahriman was to be placed at the eastern-most point at the back of the stage, a powerful sculpture of balance between the binding and releasing forces.

51

Two spaces interpenetrate each other, the larger one where the audience can "rest", and the smaller one where the "movement" of eurythmy or mystery drama can take place. The larger space of the "finished work" could therefore look into the smaller space of the "becoming". The Goetheanum brought the wide spectrum of all the arts together into one harmony. Imagine a person standing in the centre, asking the question: "How can I move from the 1st and arrive at the 2nd form of the pillar's base? How do I overcome the space between, which is like a kind of nothingness?

This person could perhaps be standing between the 1st and 2nd columns wrestling with the problem of metamorphosis. The interior was arranged so that it was possible to experience the whole symmetry and power centred at R, the intersection where the lectern stood, and by looking up, to see the pillar beyond in the small cupola. Each pillar of the smaller cupola was opposite the spaces between the pillars of the larger cupola 42. The six spaces or transitions between the seven auditorium pillars related to the six pillars on the stage.

So a questing observer would have seen a wonderful and exact order of transition from one form to the next, seeing in their metamorphic unfolding an experience of the forces of transformation which led to a living and spiritual will towards artistic creativity.

Even the woods chosen for carving each form were entirely relevant to the process of transformation.

1st Base (of pillar) in large cupola: White beech
1st Capital in small cupola: Beech and Ash
2nd Base in large cupola: Ash
2nd Capital in small cupola: Ash and Cherry
3rd Base in large cupola: Cherry
3rd Capital in small cupola: Cherry and Oak
4th Base in large cupola: Oak
4th Capital in small cupola: Oak and Elm
5th Base in large cupola: Elm
5th Capital in small cupola: Elm and Maple
6th Base in large cupola: Maple
6th Capital in small cupola: Maple and Birch
7th Base in large cupola: Birch

These forms lend very real and concrete assistance in schooling us towards a true feeling for form and its creativity. They can lead us from the formative world of "finished work" towards the process of "becoming" and its effect.

Rudolf Steiner said: "At the point where the two cupola spaces intersect one would have the feeling right from the start that an inward working of exchange could take place between the purpose of the one part of the building to that of the other. To a certain extent a sense for a rhythm could be developed between the larger and smaller spaces … One could ask: how do the smaller forms arise out of the larger ones in the two cupolas? (i.e. the forms of the smaller cupola from those in the larger cupola). The answer is: if someone would dance the forms of the larger space according to eurythmic laws, then the forms of the smaller space would arise".[4]

Such all round coherence is unique in the history of art. It is a fruitful source for drawing the metamorphosis of the forms at the base of the pillars which is the following task. This process of transformation from form **40** to **41** is very visible in the 1st capital of the smaller cupola **44**.

Practise form **43**, and then let **44** influence a kind of dissolving and recreating into form **45**. **44** is not simply a kind of transition, but it arises out of the realm of "becoming" – a true process of the formative forces. These forms from Rudolf Steiner, translated into line drawings, provide an excellent opportunity to be active in the "thinking/willing" and "willing/thinking" process, on the level of creative forces and their effects.

The next step is from the 2nd base motif **46** to the 3rd **48**. The effect of the transition process is visible in the capital form of **47**: the force from above withdraws, a new force strives upwards from below. As a result the leaflike form dissolves and rises, and a chalicelike form develops underneath **48**.

The metamorhposis from the 3rd form **49** to the 4th **51** is a dramatic enhancement. The picture of the transition form and its influence **50** shows a kind of flamelike force and at the same time receives a plunging incision from above. As a result the chalice form lifts away from the ground **51** and joins at two places at the upper edge, though still pressed downwards in the centre.

The movement from the 4th base to the 5th **54** is visibly a very decisive one, almost like a turning inside out. The capital motif **53**, has two unlimited forces from below striving upwards, and in the centre a droplike form descends. This process powerfully affects the lower movement of **52** on either side in an upwards direction while the centre form contracts **54**.

The metamorphic process continues its effect on the 5th base **55**. The two forces lift further **56** giving rise to a kind of "empty space" where a tiny form appears, noticeably similar to the original form of the sequence. The drop form hangs suspended in the centre. The previously-joined form at the bottom lifts into two columns **57** and the centre drop remains connected to the upper edge.

The last step is from the 6th to the 7th base. These forms show yet again how the process of metamorphosis is complete in seven steps. The forms become simpler. The side columns **58** flow down together in **60** and the centre drop becomes independent from the frame. The related capital gives this final step its impulse **59**.

The more you practise these in ever greater freedom, the more intensive and productive will be this journey of transformation.

The seven base motifs are by Carl Kemper. When placing them next to each other **61 – 67** they appear as parts of one organism. It is tempting but misguided to compare them to nature forms. They are not illustrations, but show artistically a rhythm of evolution/ involution, an archetypal picture of the development and rhythms of growth in a plant. A feeling for form allows us to follow this process quite clearly from **61** to **67**. The notes are Carl Kemper's own.

This organic and lively sequence of transformation of line motifs has no premeditated element to it. Rudolf Steiner spoke of his own creativity as: "you see, one had the certainty that there were no human or arbitrary things smuggled into it, but rather that is was worked out of the life of the forms themselves. One was united with the cosmic creative world itself,

also with the entire plant metamorphosis and that which works and weaves in nature, grasped at another level. That which is done is not just humanly allegorical, but to a certain extent woven into the working of nature and the way in which nature creates".

Now we are ready for an important and significant step! So far only the single motifs have been studied; the next task is to draw them sevenfold into a seal. Exercises **68 – 85** are the seal forms: each page shows the two base seals below the capital seal of the smaller cupola, the impulse for metamorphosis.

Drawing the form seven times is rewarding but difficult. Carl Kemper instructs us: "not to turn the paper! It intensifies the will to draw the form from several angles. Persevere to the end".[1]

The beginner need not take such instructions too literally, but the effect of the seven times repeated challenge can be felt as an enlivening movement. The proportions can be very free to begin with and get increasingly closer to the given examples.

A world of wonder is eventually visible. It becomes persistently more obvious that each form relates to the previous as well as the following one. It is increasingly apparent that the "real" form is invisible, giving the seal a musical quality. These seals are not decorative vignettes or mere ornaments, but can arouse deep inner experiences. When sensing these forms, the straight moving into the rounded and the rounded into the straight, how the rigidity dissolves into the fluid and then back into form and how the resting element comes into movement and then rests again; we become aware of the spiritual quality of these seals.[5] They begin to speak a language, they become as a "larynx of the Gods". Just as the human being has the larynx as a speech organ, so in the drawing of these forms a "larynx" is created through which the "Gods may speak to Mankind".[6]

Having drawn and observed the complete sequence of the seven metamorphic steps as a whole organism, another interesting phenomenon may appear. As in any true metamorphosis certain steps relate to others in the way of polarities. Step 1 with 7, 2 with 6, 3 with 5, and step 4 stands alone in the centre, both as high point and also as transition or pivot point of the scales. This was not premeditated by Rudolf Steiner or constructed, he comments: "what was very surprising for me was when I compared the 1st pillar with the 7th, the 2nd with the 6th, and the 3rd with the 5th, strange congruences showed themselves".[7]

Drawings **86 – 91** attempt to make these congruences visible. Carl Kemper drew the sequence of the seven base seals in his book *Der Bau*. In 1952 he printed the same sequence again and in both cases he tilted the first seal by 45°, making the congruences more aesthetic. Though not geometrically exact, the relationships are convincing: **86:87, 88:89** and **90:91**. The one seal is drawn in line with its partner shaded in.

Drawing **92** gives an overview of the remarkable flow of seal forms, from the pillar bases of the large cupola (auditorium) to the pillar capitals of the small cupola (stage).

May these forms become "soul nourishment" for the keen student. May they permeate artistic creativity with light of wisdom and warmth of love and help to re-enliven the student to a soul-spiritual awakening of the subject matter.

# 1/7 and 1/14 DIVISION OF THE CIRCLE

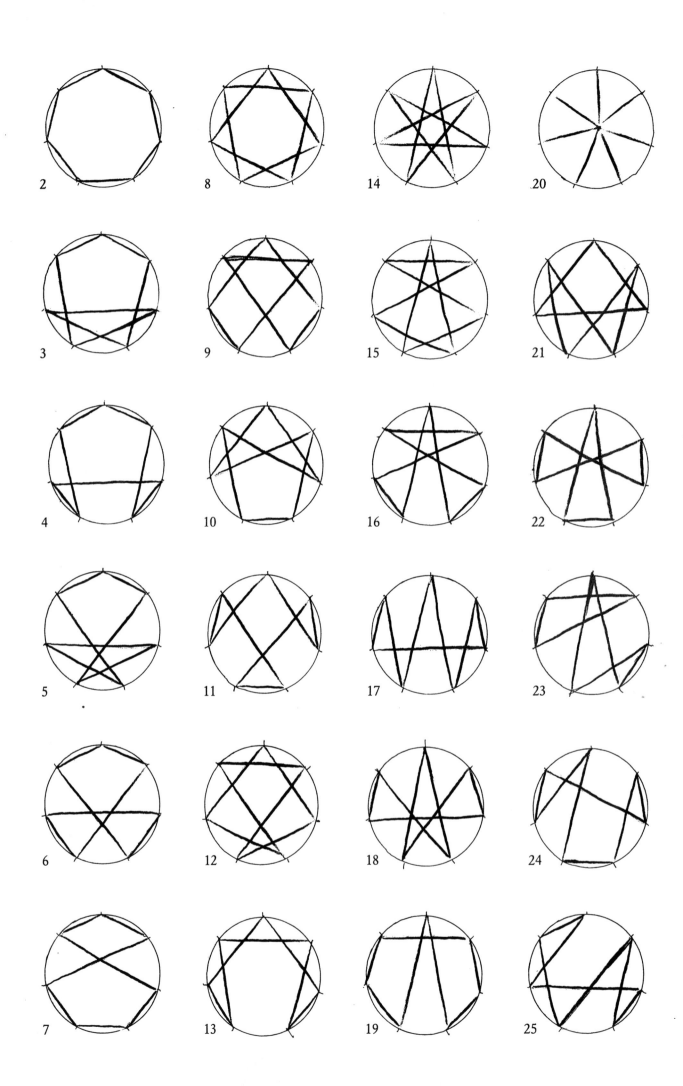

26

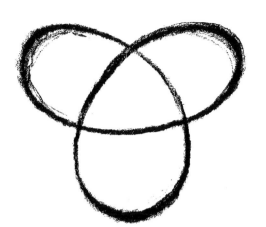

27

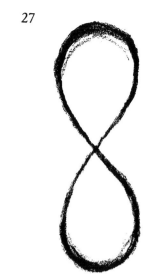

28

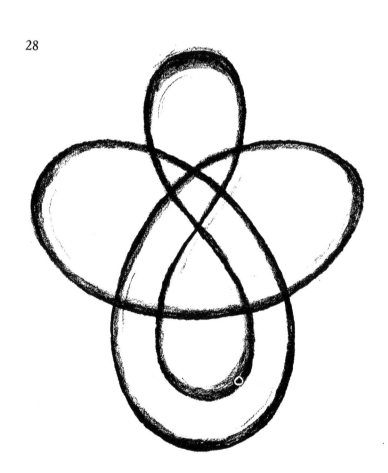

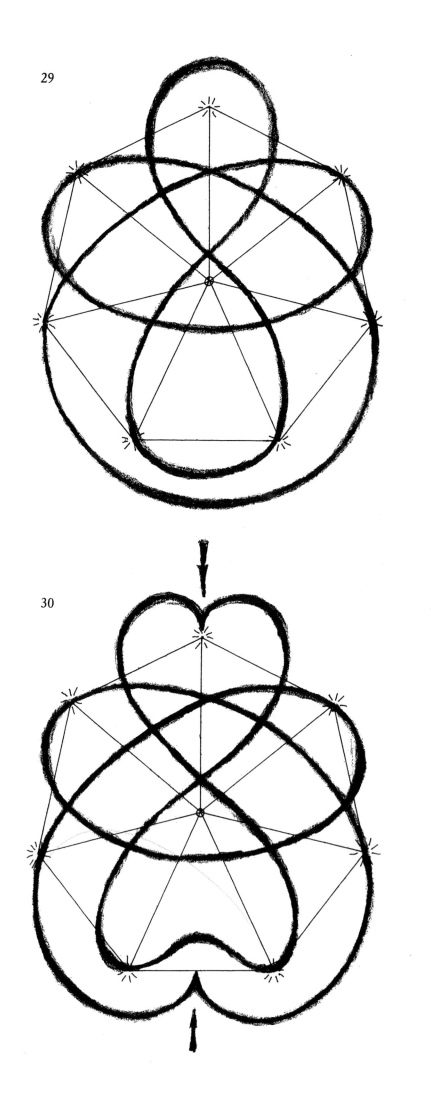

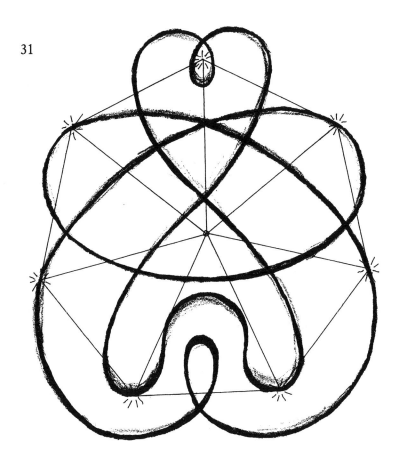

31

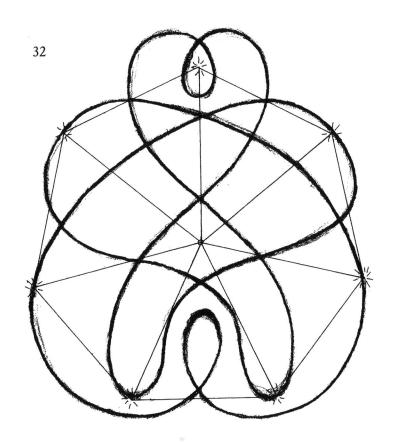

32

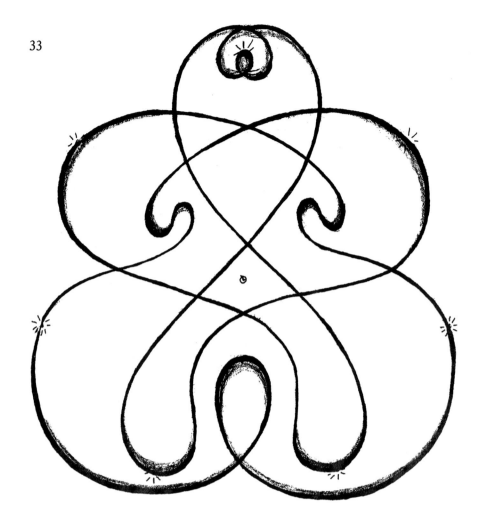

The "Butterfly" form by Marjorie Spock given to Carl Kemper

This form was originally conceived by Marjorie Spock about 1933 while working with seven eurythmy students on forms arising from a study of acceleration and intensification, deceleration and de-intensification. It begins with an outwinding spiral and ends with an opposite, inwinding spiral, reaching a dynamic maximum and turning point in the fourth movement. Carl Kemper, the sculptor, was interested in the form and was given a copy of it. This was found among his papers and inadvertantly identified as his design by his biographer, who printed it as such in *Der Bau*, a book about his life and work.

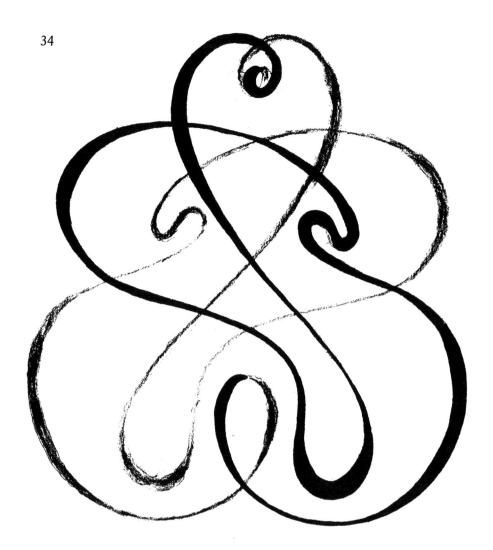

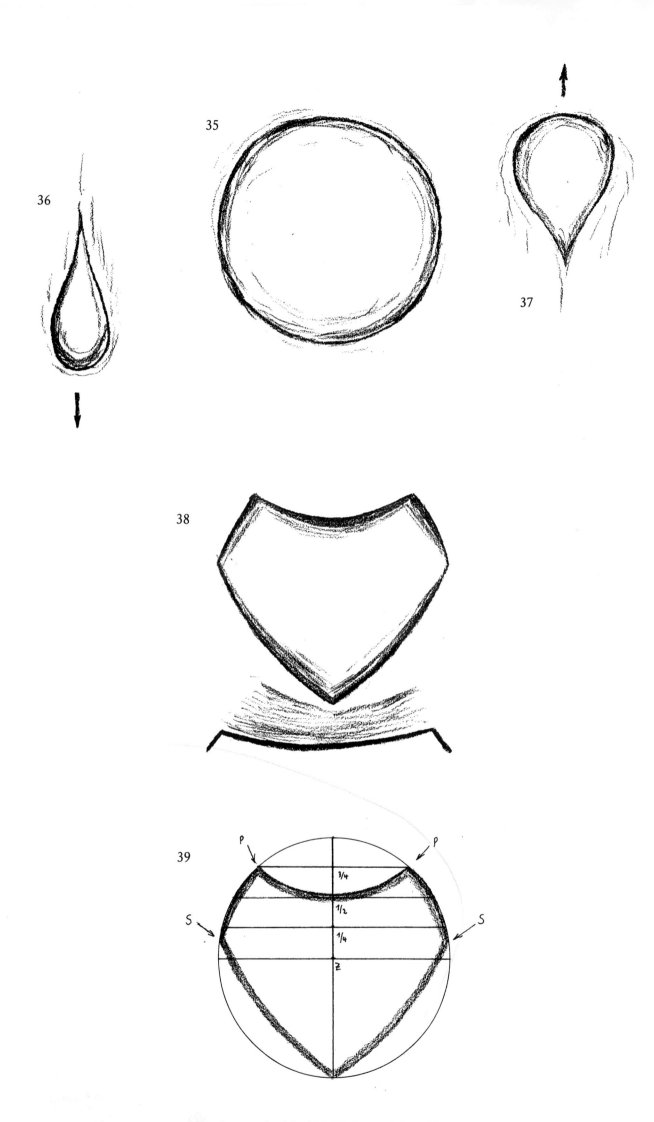

1st base

40

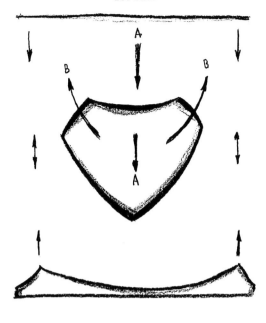

A

B

B

A

41

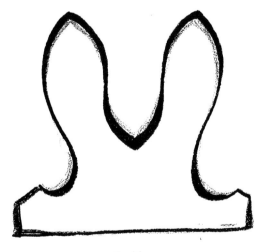

2nd base

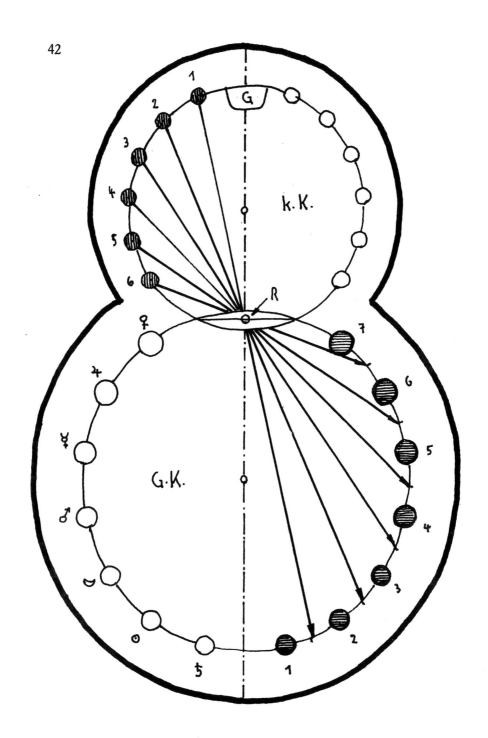

**THE FIRST GOETHEANUM (GROUND-PLAN)**

Arrangement of pillars in both cupolas

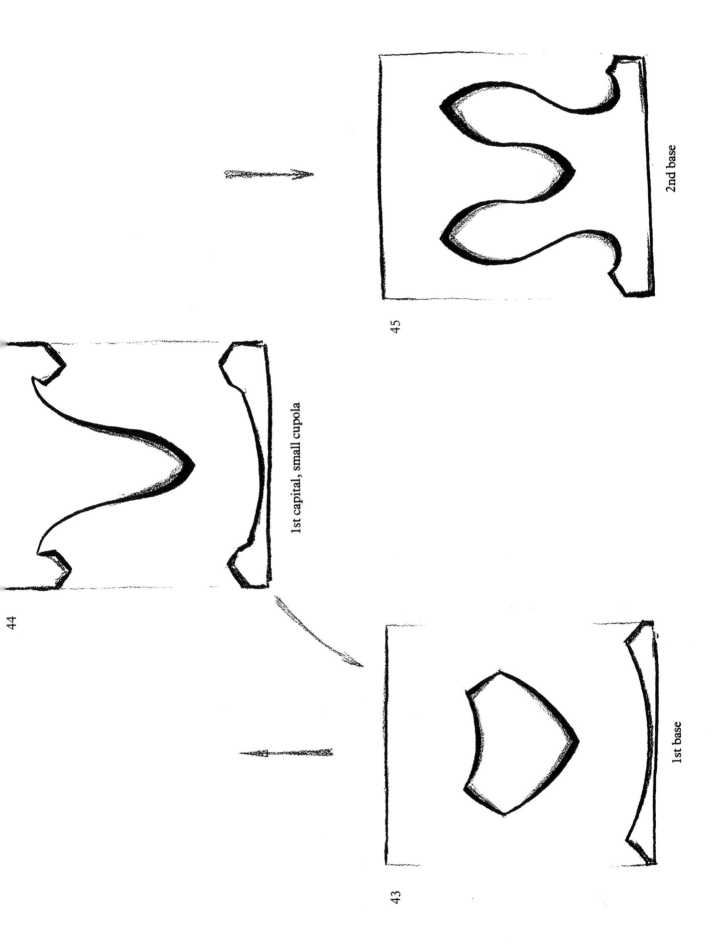

44

1st capital, small cupola

43

1st base

2nd base

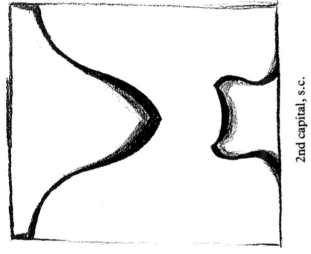

47

2nd capital, s.c.

48

3rd base

46

2nd base

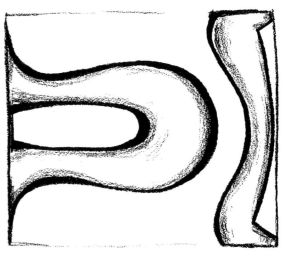

51

4th base

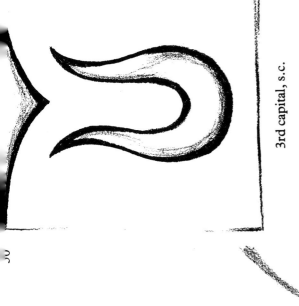

3rd capital, s.c.

3rd base

49

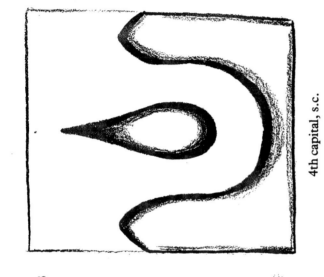

53

4th capital, s.c.

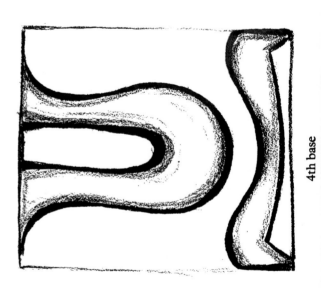

52

4th base

54

5th base

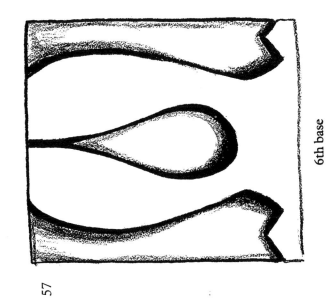

6th base

57

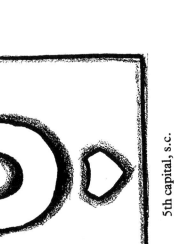

5th capital, s.c.

56

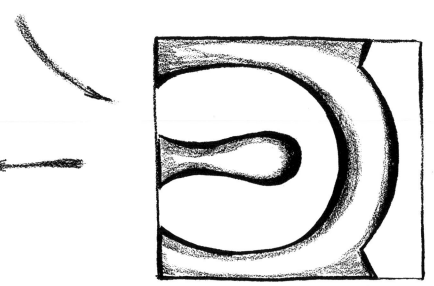

5th base

55

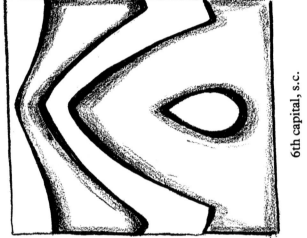

59

6th capital, s.c.

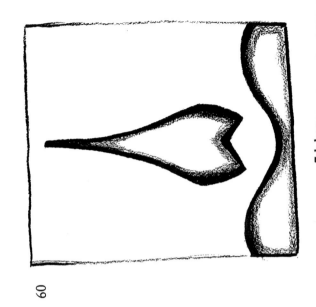

60

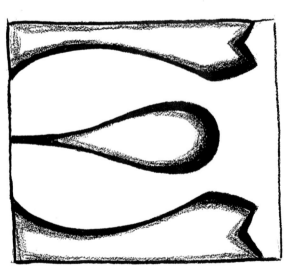

58

6th base

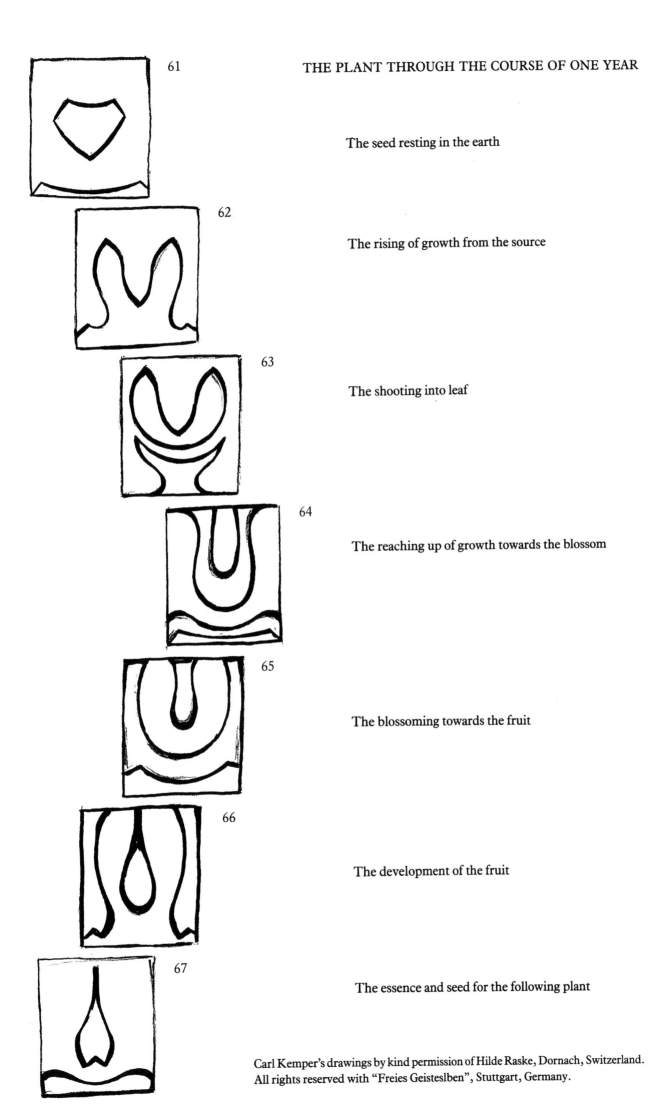

61

The seed resting in the earth

62

The rising of growth from the source

63

The shooting into leaf

64

The reaching up of growth towards the blossom

65

The blossoming towards the fruit

66

The development of the fruit

67

The essence and seed for the following plant

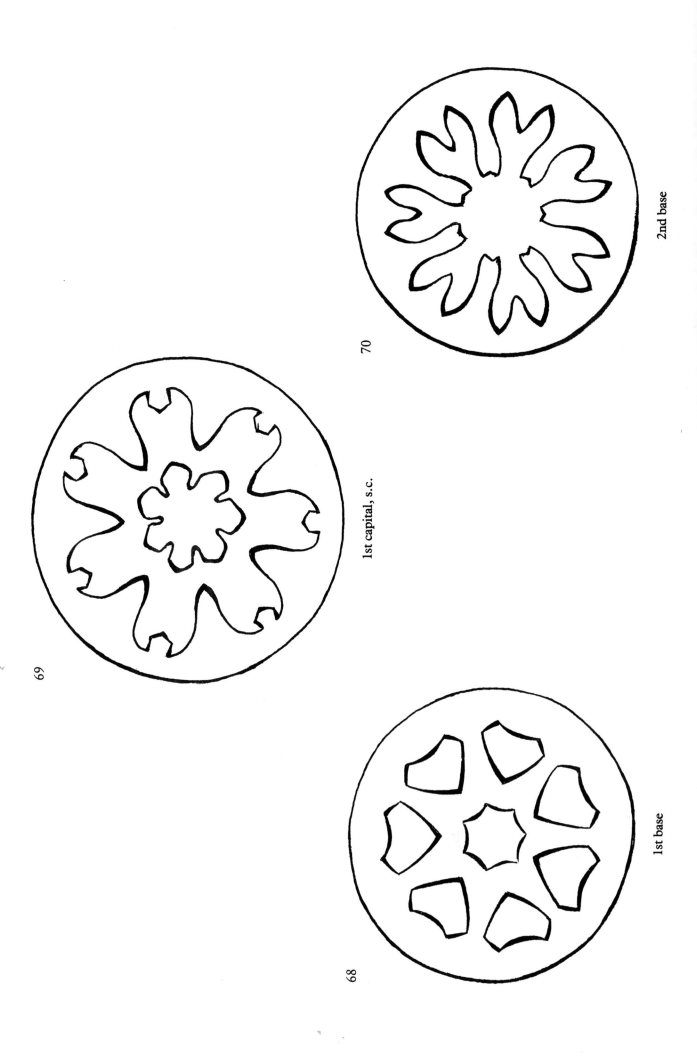

70

2nd base

1st capital, s.c.

69

68

1st base

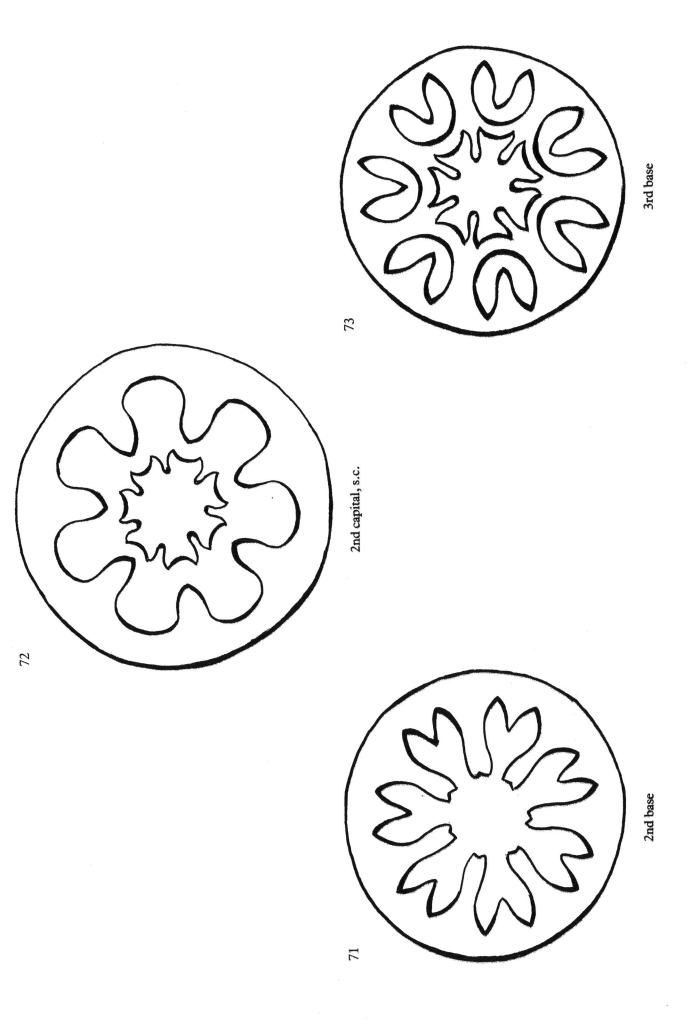

73

3rd base

2nd capital, s.c.

72

71

2nd base

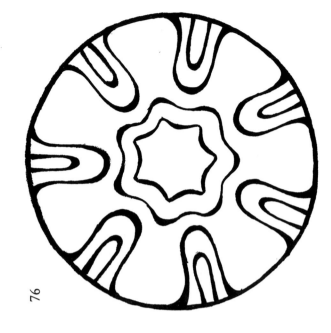

76

4th base

75

3rd capital, s.c.

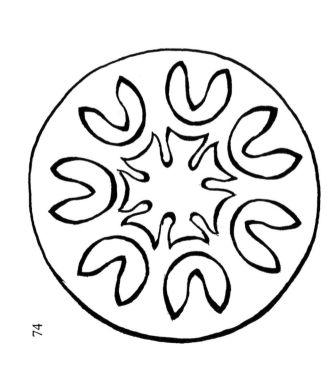

74

3rd base

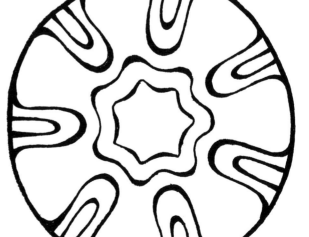

78

4th capital, s.c.

79

5th base

77

4th base

82

6th base

81

5th capital, s.c.

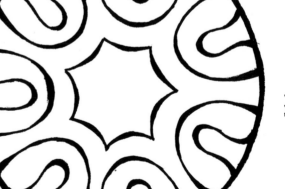

80

5th base

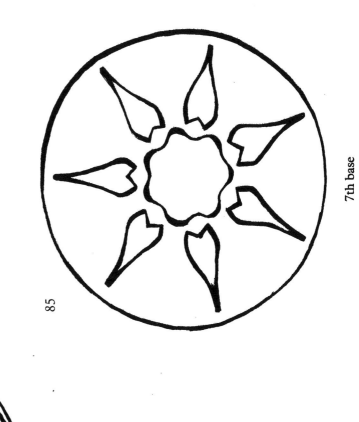

85

7th base

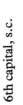

6th capital, s.c.

84

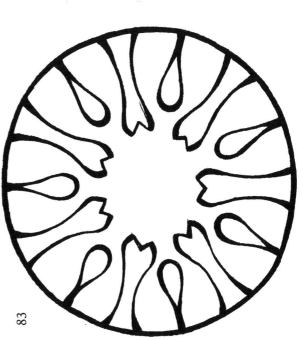

83

6th base

# CONGRUENCES

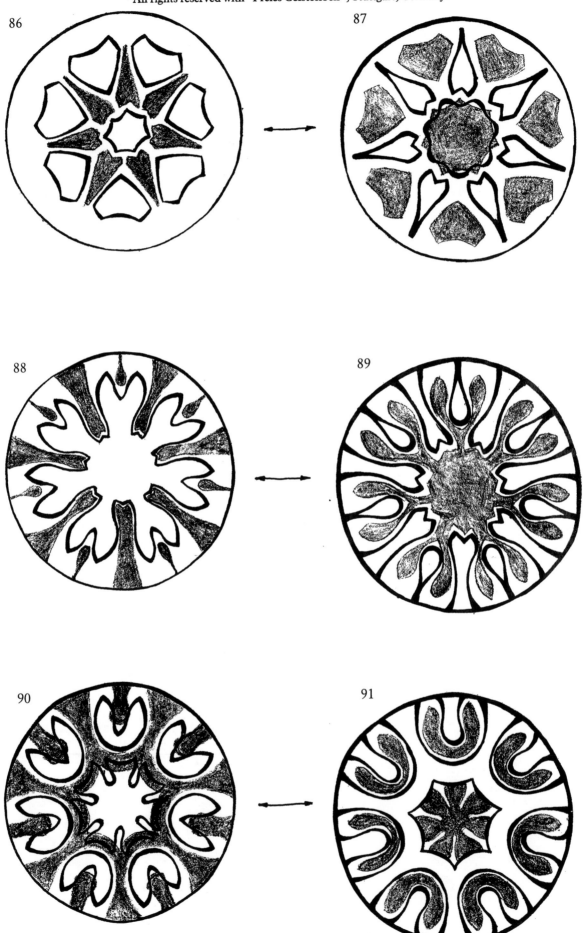

SEALS OF THE PILLAR CAPITALS IN THE SMALL CUPOLA

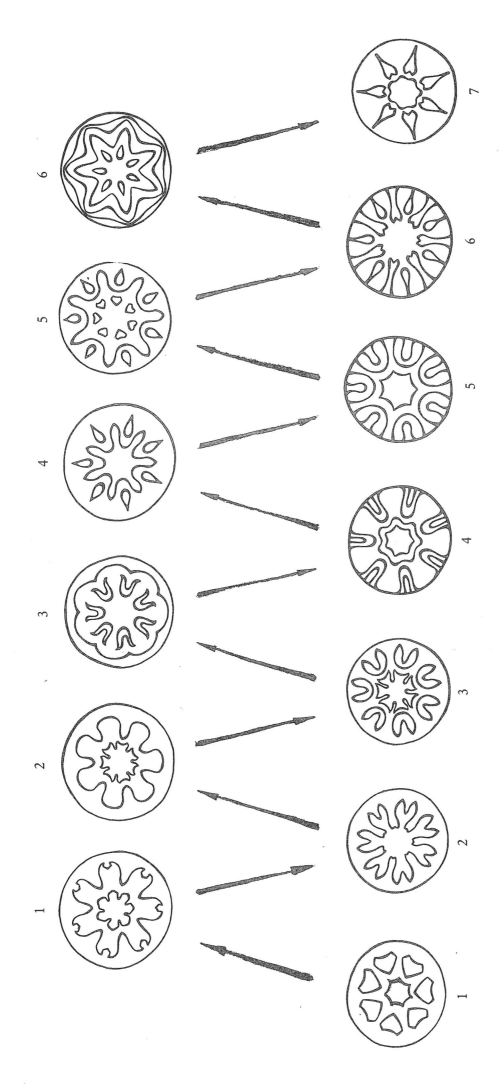

SEALS OF THE PILLAR BASES IN THE LARGE CUPOLA

Carl Kemper's drawings by kind permission of Hilde Raske, Dornach, Switzerland.
All rights reserved with "Freies Geistesleben", Stuttgart, Germany.

92

# SECTION XII

Sections IX, X, and XI have been a preparation for the ultimate aim of the planetary seals.

The Saturn seal, "beginning of all worlds", was won from the basic elements of the art of line, the straight and the rounded. The form was a result of the artistic process without any premeditated ideas or speculation.

Through variations of this fundamental form we arrived at the impressive so-called "Mystery Drama" seals.

Section XI followed the theme of the Carl Kemper seals of the pillar bases of the first Goetheanum. The powerful interplay of architectural, plastic and painterly arts in the process of "becoming", from the small cupola to the evolution of the larger cupola, revealed forms that allowed us to sense the secrets of metamorphosis.

This artistic process is the aim in perceiving and practising the so-called planetary seals by Rudolf Steiner.[1] How they came into being has already been mentioned. The preceding exercises are important preparation for drawing these forms.

The circle and centre point are designated as archetypal pictures of the seal. Our breathing is a rhythmical movement between these two poles: in the in-breathing and out-breathing our life has existence. Goethe found words to this theme already quoted in Section VI in connection with the spirals.

In breathing grace may twofold be
We breath air in, we set it free.
   The in-breath binds
   The out unwinds
And thus with marvels life entwines.
Then thanks to God when we are pressed
And thank Him when He gives us rest.

                    (trl. Daisy Aldan)

Similar forms of "breathing", like the spiral, are found in different places throughout this path of practice. The lemniscate is also a "breathing" rhythm. The two wings of the lemniscatal movement, streaming outwards and inwards, were worked on in Section I, exercise 42.

Draw a beautiful and harmonious lemniscate, as large as possible. Into each wing then build a spiral form 1. Whilst drawing, bear in mind that the spiral reaches to infinity in both directions. For this reason the in-winding line is broken and a jump is made – a leap into nothingness through the infinity of the centre point that is not attainable in drawing – to the new starting point of an out-winding spiral. Start drawing very gently and through repeated practice try to achieve as beautiful a harmony and proportion as possible.

The whole continuity of movement can now be brought to "speak". The "two graces" (Goethe) can be felt in the basic form of the lemniscate 2. Do not speak out loud when you are drawing, but allow the words to sound inwardly as the movement of the form unfolds. Or

another speaker could say the words as you draw. "We breath air in", "and set it free" can be formed in the in-winding **3** and out-winding **4** spiral. Allow the form to arise out of the movement of the speech as much as possible **5, 6, 7, 8, 9**. What could remain as abstract thought in Goethe's words can become enlivened. It is an activity of thought-imbued will, of "cognitive deed" and "active cognition" (Kemper), of a movement along the "path of willing".[2] This movement becomes the field of force for the seal between centre and periphery. Practice will lead the student to experience where the schooling, the pedagogical and therapeutic elements lie.

The first step in the sequence of the seven seals is that of Saturn, as described in Sections IX and X. Draw it anew **10**. It is possible to experience the quality of "resting within the form" (Kemper) in the "impersonal" and "cosmic" balance between the peripheral forces on the outside and the centre strength within. But there is also a certain mood of anticipation: the form does not wish to remain so forever; if left to rest it would become solid, it lacks life.

We can bring this form into metamorphosis, not just in variations and polarities as done in Sections IX and X, but transformed through the point of "nothingness", the process of "death and new becoming" – Section XI.

Help to understand the base seals came from the capital forms of the small cupola, which hinted the way from the "finished work" into a "new becoming". No such help is to be found for the planetary seals regarding one transition to the next. It is false even to assume a corresponding relationship of transition between the capitals of the large cupola to the so-called "thrones" at the base of the pillars of the small cupola. At least they do not for the moment give the corresponding impulse to drawing. Nor can help be found, for drawing, in the beautiful architrave above, which moves from one capital to the next in the large cupola. The forms that lie between one seal and the next are not relevant. Such seeking was often discouraged by Carl Kemper, as the metamorphosis unfolds on quite a different level. The "finished form" must vanish completely, dissolving utterly in the process, in order to be newly born and arrive at a "resurrection".

The sense organs for observation to assist the creative and formative process are not as yet present within us. Rudolf Steiner has given indications for a path of schooling to develop such organs.[3] However, much will depend on whether any human beings are willing to enter the dead realm of "finished work" – a result of ordinary thinking – and win through to reach the world of formative forces.

The drawing of the planetary seals can be a part of such a path of schooling, because these forms open up the world of "etheric formative forces" for us. On the planetary seals Rudolf Steiner has the following to say: "Let us assume we direct our physical eye upon any one of these forms. It is not just the physical eye which sees it, but the whole organization, in particular also the streaming of the body of formative forces, which comes into a quite distinct movement, stimulated by the course of the line through the form, so that the life body has different movements within it after beholding one form or the other".[4]

When the activity of creating these forms is added to the mere beholding, the effectiveness of the above is greatly enhanced.

Rudolf Steiner says further: "If you live into such forms with sensitivity, then you will find that which so orders your awareness as it could never be organized by the world of sense and which could give you an imagination for the music and harmony of the spheres".[4]

Rudolf Steiner evolved the forms in such a way that the student, when embarking on the path of drawing, becomes ever more aware of the working force of the line picture. The further effect of the movement of these forms, even if not consciously, helps to bridge the "abyss of nothingness" which at first glance seems to separate one form from another. From the outset the student is initiated into the symmetry of metamorphosis.

Rudolf Steiner said: "It must be the first step of initiation: to enable the human being, during the course of the day, to do something which unfolds in the soul and continues to work when during the night the astral body is released from the physical and etheric bodies. Speaking pictorially, imagine the human being is given a task, whilst in full consciousness, which was so chosen and arranged that it would not cease to work when the day is passed".[5]

The drawings of Rudolf Steiner's seals constitute a gift of this kind and can be accepted as such with complete trust in the teacher. It is also possible to use them as a hypothesis to prove for yourself. This may lead to new faculties arising and growing within you.

Rudolf Steiner stated: "Every line, every curve, everything in these forms is such as can awaken dormant forces within the soul when you livingly enter into the subject matter and these forces lead to imaginations fundamental to the cosmic and thereto connected human development on earth".[4]

The seals as Rudolf Steiner drew them are themselves the subject of practice. Much may depend on one's approach to such work.

What does this mean? Speculation and experiments of bridging the forms etc. are to be avoided. The first step is to learn to draw them all in full joyful consciousness, and thereby move from mere observation to engaging the will activity. These forms cannot be varied at will, they are subject to basic laws. In the same way, no two notes of an instrument creating an interval can be arbitrary, yet these unalterable basic rules in the realm of music do not in any way inhibit the possibilities of free creativity. If you are wide awake to the "interval" between the seals the inner life can be awoken; learn to look at each seal in relationship to the previous, and also following, one. Any one motif can only be experienced as part of the whole seal-organization. Every individual seal can only be understood when seen as a part of the sevenfold whole.

"The full completeness lies in the living process of becoming" (Kemper).

To repeat: you may become aware that Rudolf Steiner did not create the seals as reproductions or illustrations of some already existent phenomena, sense perceptible or supersensible. These seals are "future forms".

Rudolf Steiner said: "That which is represented in the seven seals does not as yet exist in the cosmos. It lives in that which wills to become and will be. It will be substance and form in the future and when looked at in the correct way they will work livingly".[4]

His advice is obvious, respect the seals, do not merely use them for casual decorations or wallhangings.

Now try and draw the second seal, the Sun seal. What kind of transformation is here revealed 52, 53? First allow both pictures to work on you. Then observe certain individual motifs and use them as preliminary exercises. A musician also practises certain separate passages before weaving them back into the whole. Where before in the Saturn seal there was a mineral quality to the centre motif, in the Sun seal a separation, rounding and living radiating form steps in 11. Sense the dynamic of the line in the symmetry and balance, as well

as the streaming quality next to and between the forms **12**. Due to the living force radiating from the centre, the outer form is altered **13**, extending on either side, and it only flattens and breathes inwards in the middle of the line. However, the force that creates all these changes actually comes from the periphery with considerable energy. A mighty power of contraction is centred just there where the Saturn form was expanded **14**. This dynamic works very strongly upon the centre, which also alters the inner motif completely. The space between the two motifs is very lively **15**. The little star form in the middle of the Saturn seal is simultaneously drawn through the centre point and reappears on the opposite side as a little seed form in the sevenfold rhythm of the whole seal **16**. In the drawing by Carl Kemper these seed forms are closed, but it was reported by Flossie Leinhas that Rudolf Steiner drew them opened towards the centre and only closed them in the following seal, hence the detail in the drawings of this series **16**.

Drawing **17** shows the seal form within the geometrical seven-sided, seven-pointed star. Like the musician who has to look closely at the music during practice, who may even have to use a metronome, the drawer may also make a structure of geometrically precise proportions within which to practise drawing. This "scaffolding" will only be needed to start with so that during practice you may become freer and surer in the forming process. As assistance to the seven-sided structure the template of the previous section is repeated **91**.

The Sun seal **18** shows a whole new gesture – at one and the same time a contraction or going inwards from the periphery as well as a growing and unfolding force from within. "Life comes into being and is visible" (Kemper).

In the transition of the Sun seal to the Moon seal **54, 55** the contracting force from the periphery is further enhanced. The outer motif condenses to an incision towards the centre at one place and a new feature appears like a stem with a threefold blossom radiating inwards **21**. (The dotted line is the Sun seal pattern.) A double motif is developed out of the open and outward streaming Sun seal form: it draws itself inwards and also faces outwards like a receptive chalice. On the outer periphery small hovering waves bring a balance to the inner chalice forms.

The inner seed forms have become a little larger and are now closed and even slightly cornered.

Draw some soft and gentle wave forms as preliminary practice for the outer motif **19**. The moonlike theme of the "yearning/reaching" of the blossom towards the receiving chalice is shown in the proportions of exercise **20**. Drawing **22** in the geometrical structure shows the correct proportions and some interesting relationships. The entire Moon seal reveals a wholly transformed mood **23** "of yearning, of inner fulfilment" (Kemper).

The movement from step three to four, to the Mars seal, is filled with momentum and drama **56, 57**. What was previously hovering in gentle accompaniment now cuts inwards with decisive force. Practise this transition **24** and enhance the gesture as though guided by a sharp sword **25** which causes a kind of breakthrough into the seedlike forms **26**. The centre becomes free and at the same time "ego conscious". The two Moon forms of threefold blossom and chalice have joined into one form **28** and the surrounding line has stretched, offering the student a remarkable challenge. Practise the transitions to become ever more sensitive to their differences **29, 30**. Pay special attention to the "musical interval" at points A **27**.

Drawing **31**, illustrates the proportions of the Mars seal. If you try to draw individual features within the geometric structure in different proportions you will find how surprisingly "true" Rudolf Steiner's whole form is. The Mars seal is the 4th and therefore also the middle point in the series **32** and as such it shows us the enclosed "centredness" and ultimate reaching-in of the peripheral dynamic. The form is "gathered together with an iron force and self-aware" (Kemper). It has become a new power from within that works in an outward direction. This Mars form shows an inner tension, creating "suspense" as to what will develop out of it.

There are some useful preliminary exercises towards the next step. Draw a well-rounded circle with a radiating straight line to it **33**. Then allow the rounded form to turn and the straight line to stream upward harmoniously together **34**. This form has been practised before, it is a picture of balancing polarities, of equilibrium and therefore a healing form. It is in fact the staff of Mercury depicted in ancient drawings of Asclepios, the God of healing. Embedded in this form is the archetypal woven ribbon which is here a picture of the two snakes that wind and twist around the staff **36**. These forms may be found in two different ways in the illustrations of Asclepios: one resembles "dissolving", reaching upwards, the other is held downwards as though "newly bound". This double quality can also be found in the main motif of the Mercury seal **35**: a releasing upwards and a binding downwards **36**. The movement of opposite directions is very pronounced in the seal **40**. The snakes grow out of the innermost centre as though a new beginning radiates from within, divides, and from each branch a snake is formed; one overlaps the other, from the right over the left, but the two snakes that ultimately face each other do not arise from the same root.

The three-pronged spear that cleaves its way to the centre **37** is derived from the more bell-like form of the Mars seal. Rudolf Steiner and Carl Kemper both drew these snakes with eyes and mouths **36**. This feature brings the drawing close to a pictorial imagination, but if you leave those details aside you may come closer to the pure movement of the line **35**.

The bell-like form that condensed itself in Mars and its little "drop" now dissolve and unfold to a rhythmical movement around the periphery enclosing the whole. When drawing make sure that the line retains its sweeping curves and does not just slide along the outer geometrical circle **38**. The structure **39** shows the interesting proportions of this seal.

The metamorphic step from Mars to Mercury is a mighty one **58, 59**. The Mars form is both the end of a predestined development and the beginning of a new direction into the future. A new "star" is about to rise, the morning star, Mercury **40**, "to be in the becoming, never standing still" (Kemper).

A complete turning inside out occurs in the transition between the 5th and 6th seal, Jupiter **60, 61**. The line that encircles the Mercury form in droplike movements towards the middle now penetrates right through into the centre where it inwardly gathers itself to reach out in a sevenfold armlike shape. The inward curvatures are transformed to an outward swell and the outer curves move inwards. The three-pronged spears, however, withdraw to the periphery, unite in a swinging movement and build a surrendering and receptive gesture towards the centre. The snakes disappear altogether, like the "sacrifice of the snakes" from Goethe's fairy tale. Instead a beautiful and generous movement of harmony appears in the waving rhythm, head-like shapes press outwards into the surrounding movements **41, 42, 43**, creating an almost joint-like form as response from without **44**. These two elements

appear in the Jupiter seal as separate motifs 45. When drawing this movement, special care must be taken in balancing and sensing the proportions of the lines to each other, as for example at points A in exercise 45.

The proportions of the whole picture of this seal are to be found in the geometric structure in drawing 46, which, when drawn freely 47 reveals a simple but majestic gesture: "a simple, completed form of surrender, acceptance, patience and modesty" (Kemper).

The last journey of transition is towards the 7th seal, that of Venus 62, 63. The sevenfold "arm" of the Jupiter seal now condenses into one line at the centre length of that space and radiates out from the middle almost to the periphery, where it then divides and winds inwards in a double-curved form of remarkable fullness and yet visible simplicity. The outer motifs, however, are paired in a gentle swinging motion of double curvature and pointed-ness, as though "listening and echoing" around the completed centre form. Drawing 48 shows the harmony of the counter rhythms, and 49 illustrates the Venus movements on the background of the Jupiter form. Exercise 50 is the whole Venus seal within the geometrical structure.

The freely drawn Venus seal 51 clearly shows the completion of a step-by-step transition. It radiates a mood of "inner fulfilment from outer simplicity towards lofty heights" (Kemper).

Drawings 52 – 63 are pairs of comparison and 68 shows all the seven steps of the metamorphosis in sequence. This planetary sequence also follows the process of time through the days of the week from Saturday/Saturn-day, Sun-day, Monday/Moon-day, Tuesday/French Mardi, Wednesday/French Mercredi, Thursday/Italian Giovedi, and Friday/Italian Venerdi.

In eurythmy each planet is given a specific colour: Saturn blue, Sun white, Moon violet, Mars red, Mercury yellow, Jupiter orange and Venus green. You can use these colours to draw the seals, but the colour should enhance the movement of the line rather than be overwhelming. Beautiful seal drawings exist where the delicate colours accompany the movements as background.

Carl Kemper said: "When trying to express what has taken place in the transitional journey of these pictures 68 right to the 7th it could be abstractly said that the periphery, which was visibly contracted in the line, was changed in the 4th picture into a radius or radial form. A periphery is there in the end, but is a different one. It no longer contains the substance that is directed towards the centre, as the first circumference did, even though it still encircles the centre. With the commencement of Saturn the ego quality of centre and peripheral forces combine, in decisive steps, to reveal the process of evolution; seen most clearly in the 1st, 4th and 7th seal. As such, they contain the idea of the truth of development in the unfolding of the whole sequence and their beautiful forms".[6]

It is not the aim, nor is it possible, to enter into all the facets and surprising interrelation-ships of the seal transformations and their powerful language of form. Their unfolding shows a fullness of spirituality through the evolution of the world and of mankind from the past into the future.[7]

Alchemists have always recognised that every planetary stage has a particular metal connected to it. Each specific metal has the corresponding seal form inherent in it according to the laws of physics and chemistry.[8]

They also relate to particular tree species and their wood from which the relative pillars were then carved in the first Goetheanum (see table on page 89). Each planet is also connected to a particular vowel, and a corresponding movement in eurythmy. This leads us to feel that the word has become visible through the form referred to in Section XI as the "larynx of the Gods". These seven seals are pictures of the archetypal beginning and ultimate end of all living development. For each step in this series, especially when represented by the pillar, Rudolf Steiner gave the appropriate words, known as "column phrases" (*säulenworte*). When looking at or drawing these seals listen and question whilst letting the corresponding words sound within you. Martha Egner-Morell and Carl Kemper both gave specific words to relate to the seals, "seal phrases" (*sigelworte*).

Other authors besides Kemper have researched into this work; particularly Kathe Grohman, Friedrich Kempter and Martha Egner-Morell. In their study of detail and the steps of transformation they all arrived at different conclusions. The eurythmist Martha Egner-Morell pursued the process of transformation of the outer motif with convincing results 69 – 75. At the same time she stresses that all the motifs simultaneously are the reality of the metamorphosis. Therefore a consciousness of the whole should always be maintained in the detailed work. Drawings 76 – 82 show the sequence of the middle motif and 83 – 89 are of the inner motifs.

There is a further and remarkable element. In the sequence of the seven base seals the surprising congruences and quality of spaces between them were revealed. With the planetary sequence Rudolf Steiner himself admits to being surprised, after having completed the work, at the astonishing "inner symmetry" between 1 and 7, 2 and 6, 3 and 5. This points to an inner law of all metamorphosis. The following exercises are an attempt to highlight this experience.

The question is of symmetry which is not mere mirroring across an axis, but a balance of play and counterplay, point and counterpoint, between obvious polarities which in their interaction build towards a climax. Thus an approach to the secrets of metamorphosis comes closer to realization.

Make an enlarged drawing of the Saturn seal 64, or a section of it. Into this place the movements of the Venus seal and observe the amazing interplay and counter movement between them. Draw them as large as possible on tracing paper so that one can be superimposed on the other. This interplay of forms and movements gives a unique insight into the artistic effect of metamorphic laws.

Draw the Sun seal in the same way. Again it is astonishing how the Jupiter seal relates to that of the Sun in a musical and harmonious way 65. The beautiful open gesture of the Sun is responded to by a kind of listening quality of Jupiter. The outer drop form of the Sun touches the space of the thrusting arm of Jupiter and the two waving lines in their harmonious polarities enclose the form together.

The Moon seal also has a remarkable relationship of inner symmetry to its partner, the Mercury seal 66. Only the fourth and middle marker of Mars stands alone 67.

There is also a different sequence of the seals which does not illustrate the time process of evolution as in 68. The transformation of the three basic elements of outer, middle and centre motifs are illustrated in 69 – 75, 76 – 82 and 83 – 89. The seals in 90 are so ordered to give dominance to the Sun and the consequent line of connection is then no longer a

seven-pointed star, more a seven-pointed "tree". This arrangement shows the laws of the planets and their language of form in a beautiful and enclosed interplay. Rudolf Steiner encouraged goldsmiths to fashion these forms in their related metals and these have now become a new and impressive feature in the art of jewellery. The quality of the metals is enhanced by raising the language of form into relief.[9]

A student of drawing must not be sidetracked from the purity of the language of line. It is much richer than it sometimes appears. The medium of drawing can take a student through the musical flow of movement and quality of design close to the realm of the spiritual.

This brings us to the end of a long and enriching path of schooling. The conclusion is not an end but a new beginning on a pathway into the future where "the spiritual in the human being may lead to the spiritual in the world all".[2]

| PLANET | WORDS OF THE PILLARS | | WORDS OF THE SEALS | METALS | WOODS |
|---|---|---|---|---|---|
| | RUDOLF STEINER | MARTHA EGNER-MORELL | CARL KEMPER | | |
| ♄ SATURN | Das "Es" The "It" | Expectancy | Rest Within the Form | Lead | Beech |
| ☉ SUN | An "Es" Towards "It" | Life | Life Emerges, Becomes Visible | Gold | Ash |
| ☽ MOON | In "Es" Within "It" | Gift of Existence | Longing, Becoming Inwardly Fulfilled | Silver | Cherry |
| ♂ MARS | "Ich" The "I" | Clarion Call | Pulled Together with Iron Force, Conscious of Self | Iron | Oak |
| ☿ MERCURY | Vom "Ich" From the "I" | The Self | Being in the Becoming, Never Still | Quicksilver | Elm |
| ♃ JUPITER | Aus "Mir" Out of "Me" | Inhabiting | Simple, Perfect Form Selfless Devotion, Open, Waiting, Chaste | Tin | Maple |
| ♀ VENUS | "Ich" ins "Es" "I" into "It" | Harmony | Inner Quiet through Outer Simplification Towards the Highest | Copper | Birch |

1

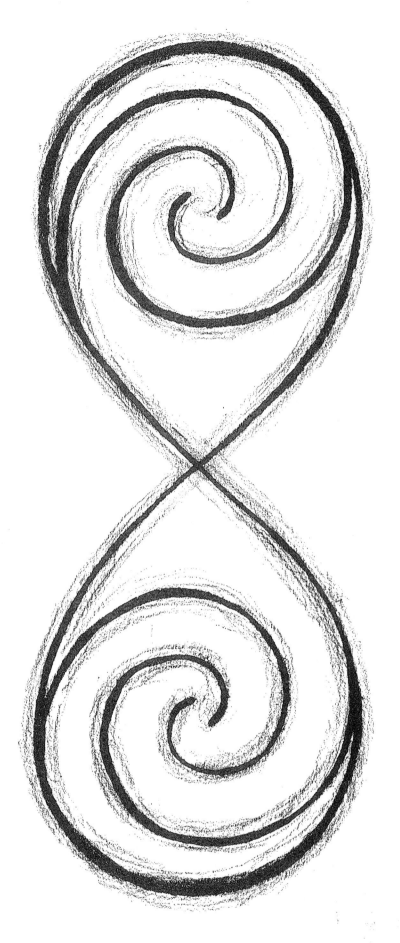

2

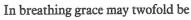

In breathing grace may twofold be

3

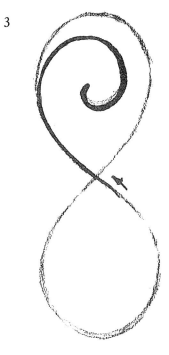

we breath air in

4

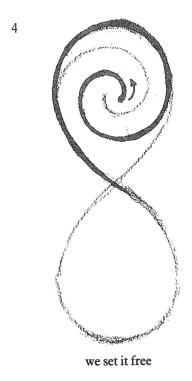

we set it free

5

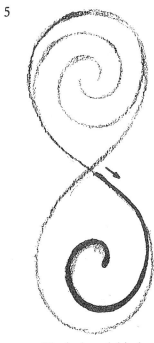

The in-breath binds

6

The out unwinds

7

And thus with marvels life entwines

8

Then thanks to God when we are pressed

9

And thank Him
when He gives us rest

Goethe

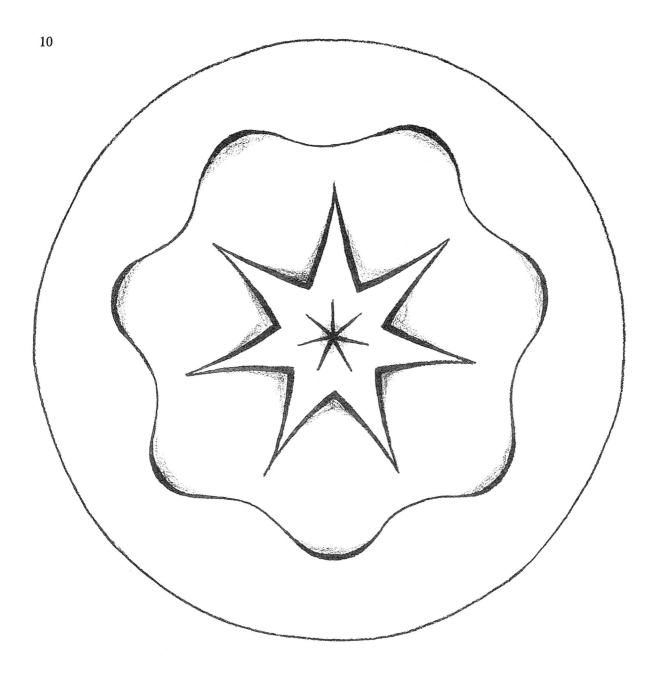

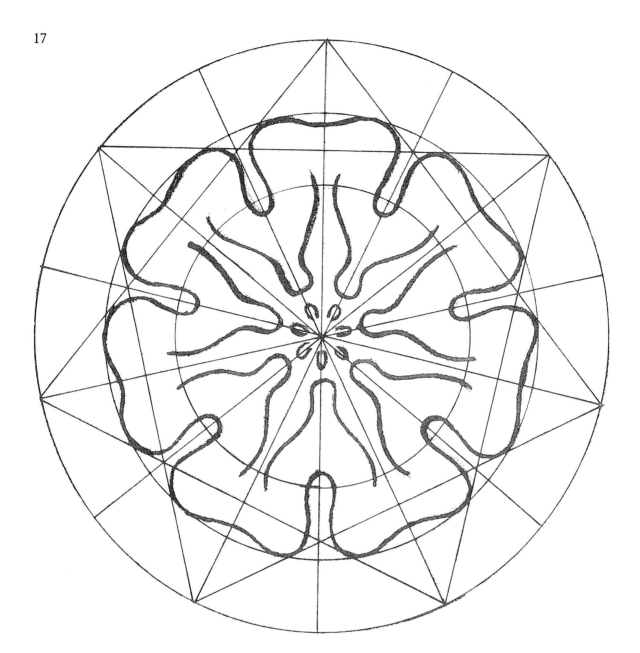

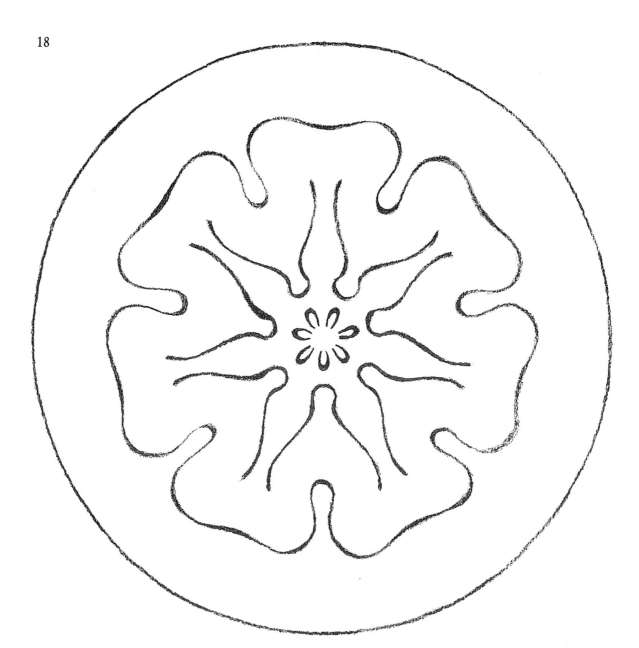

19

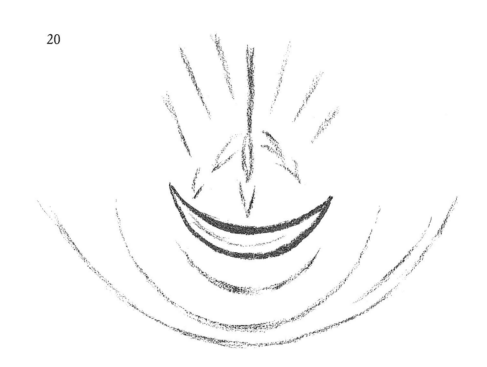

20

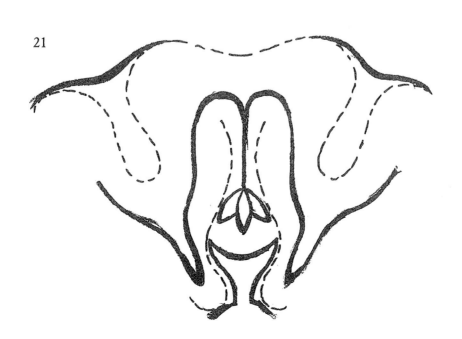

21

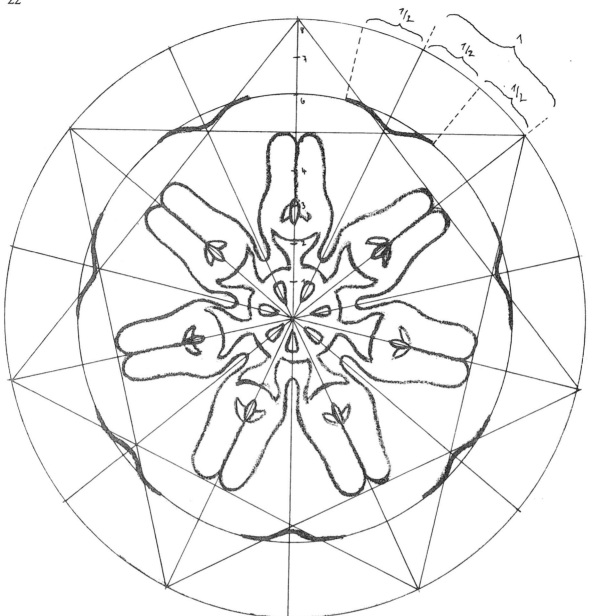

23

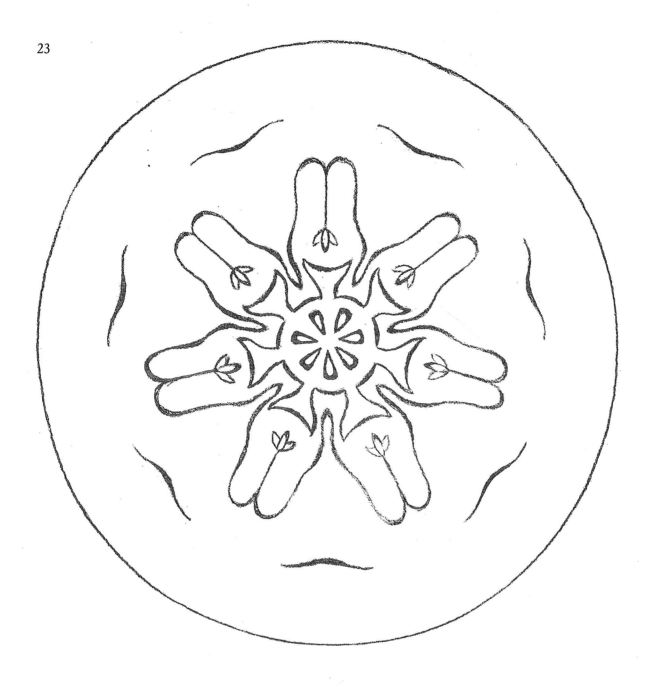

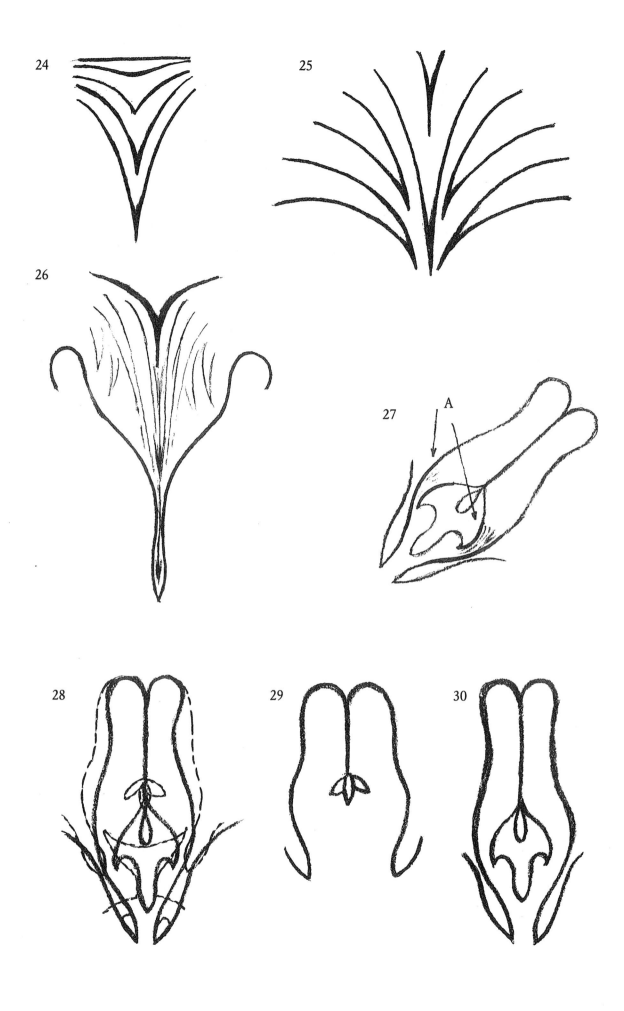

31

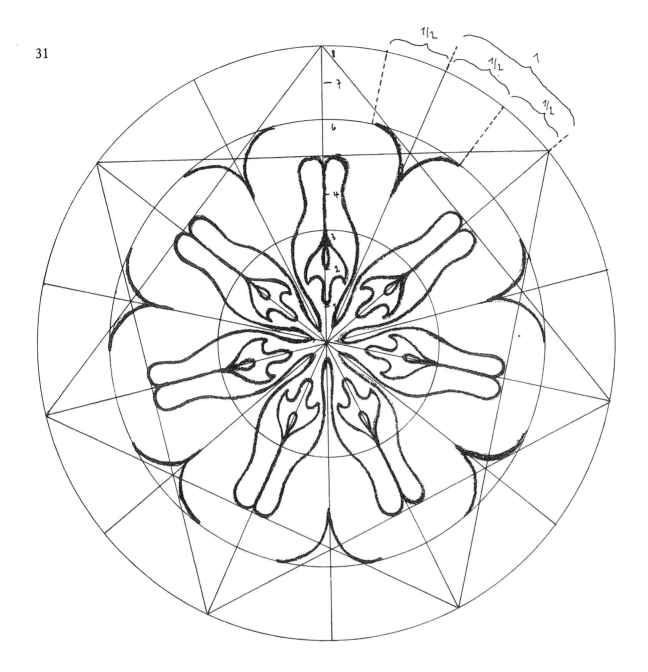

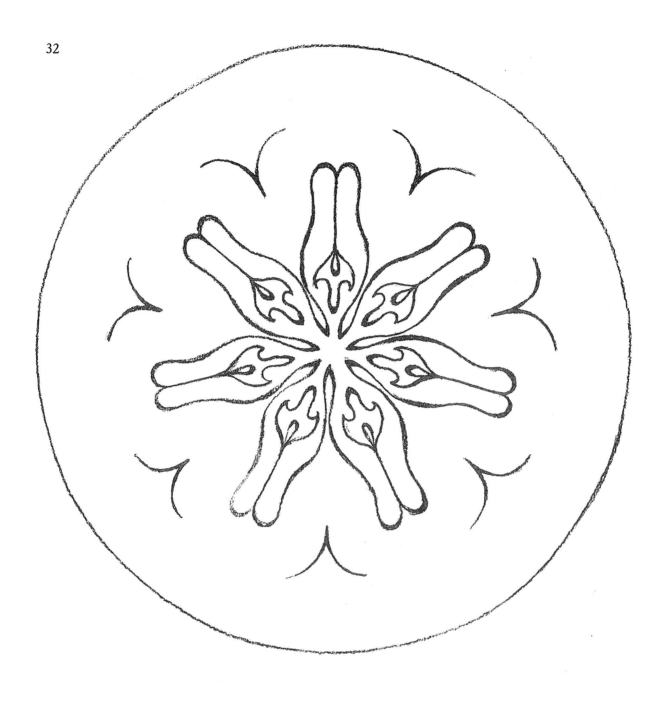

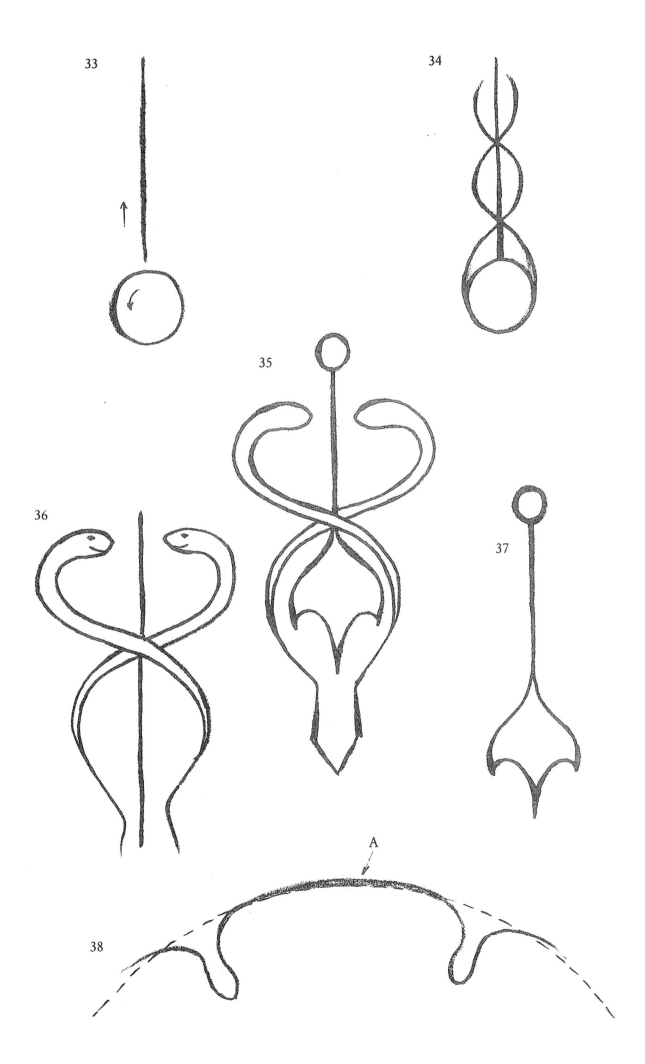

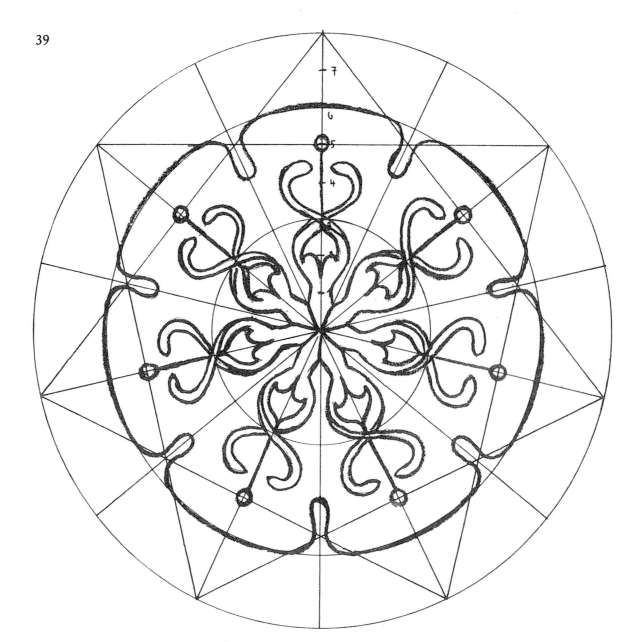

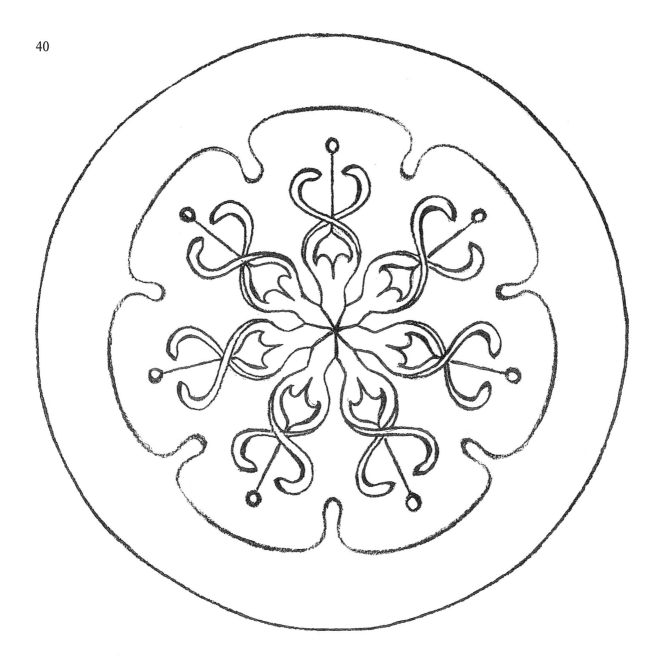

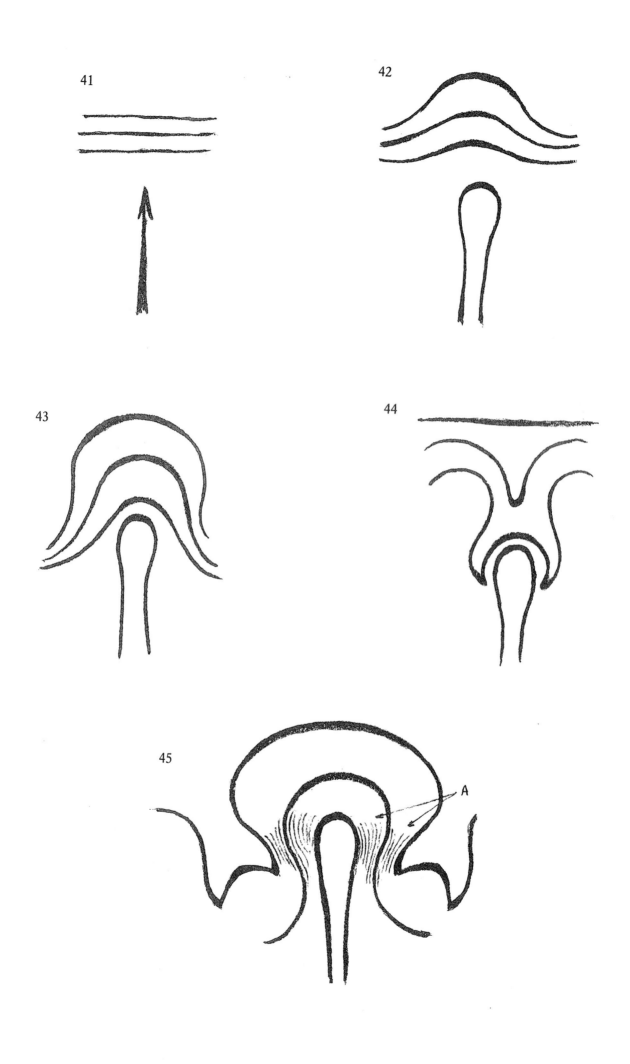

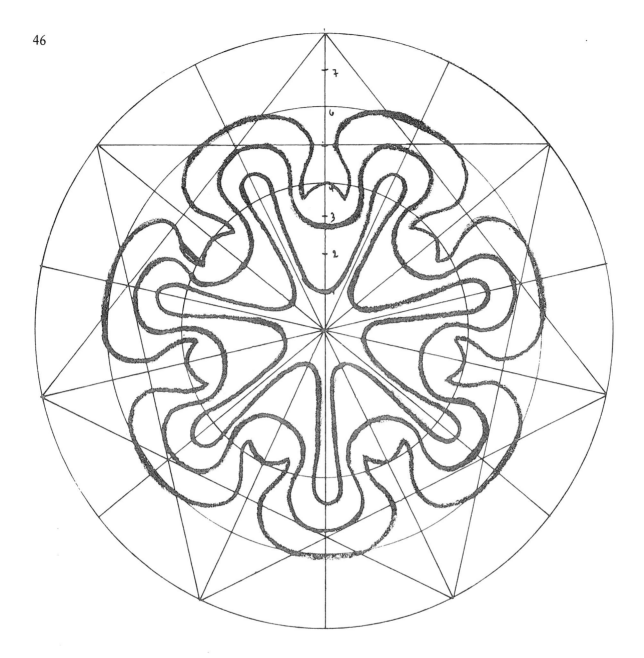

47

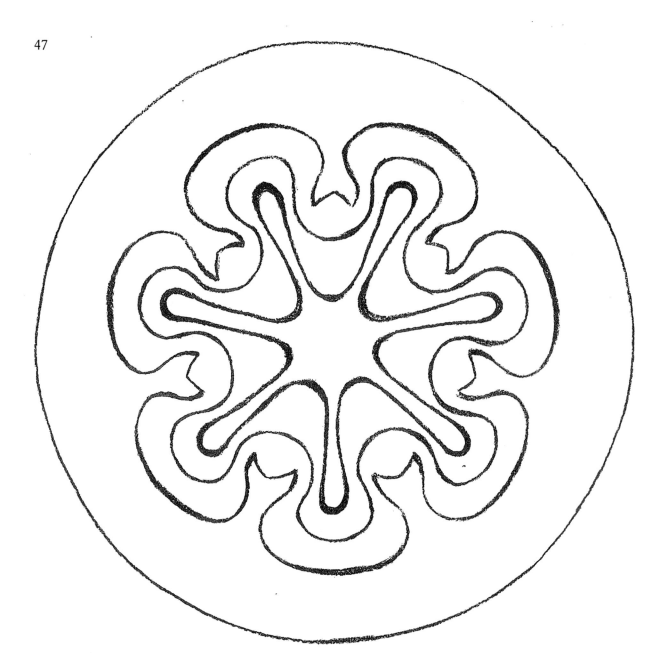

48

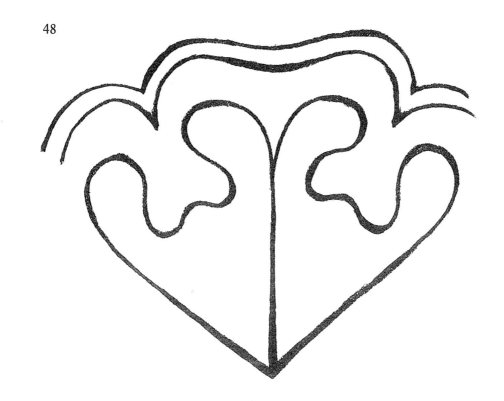

49

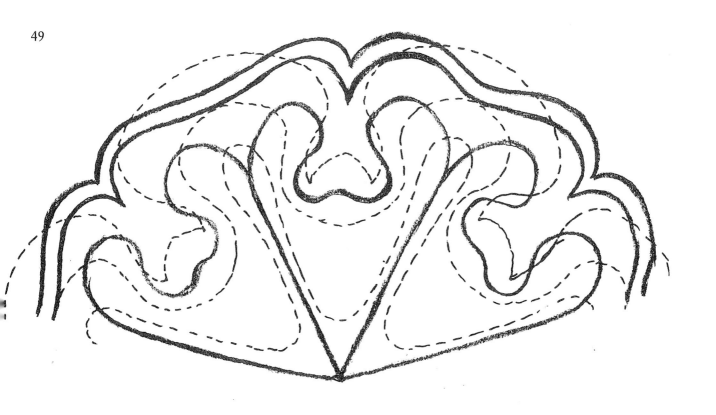

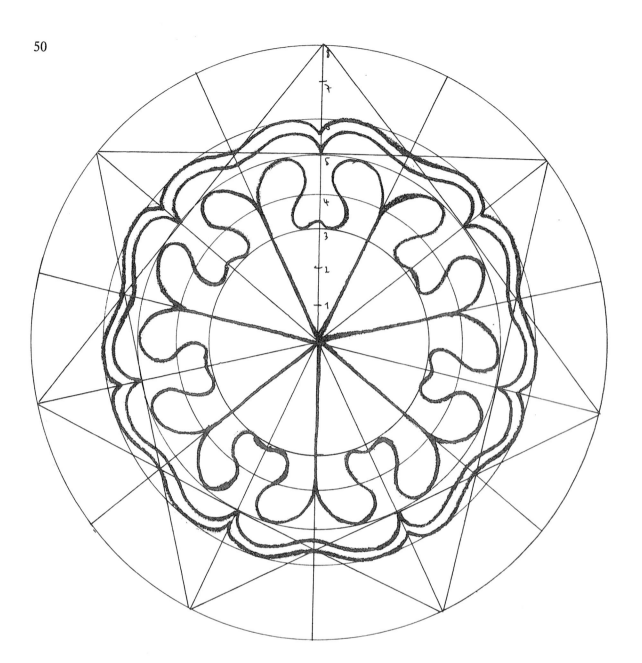

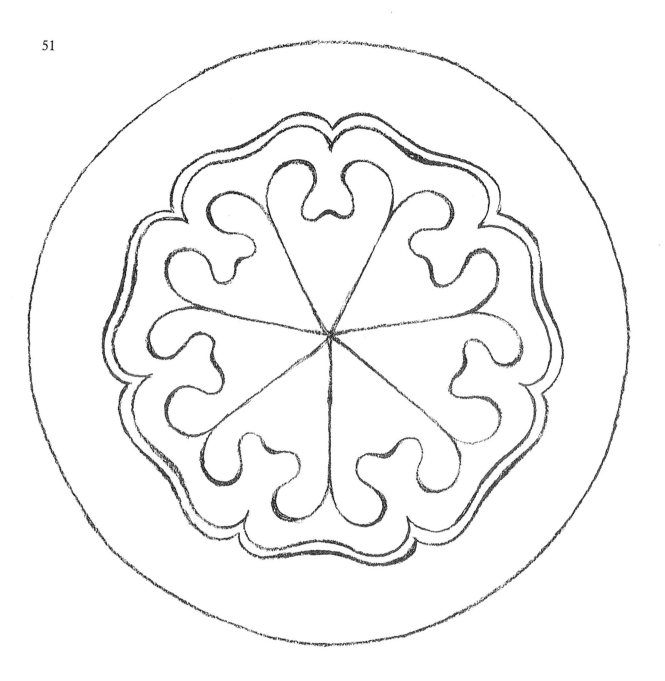

52

53

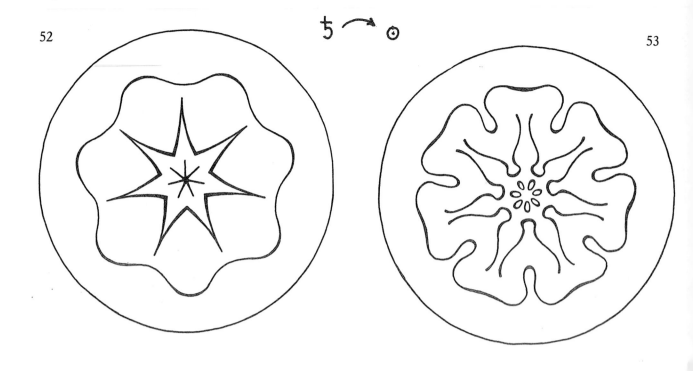

54

55

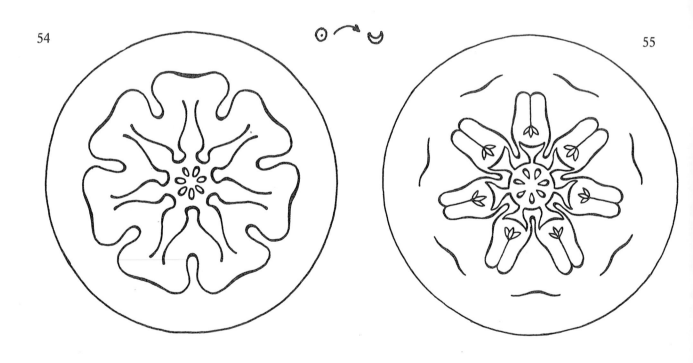

56

57

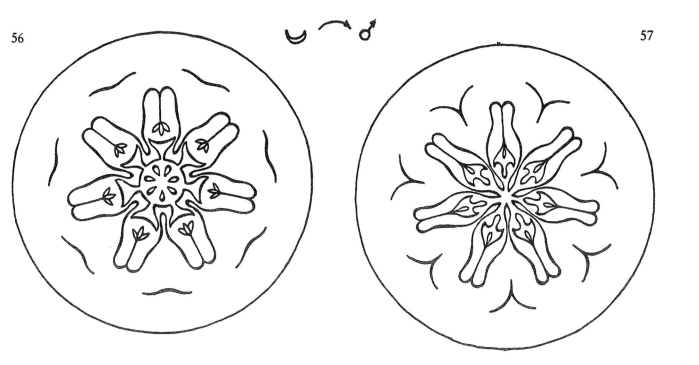

58

59

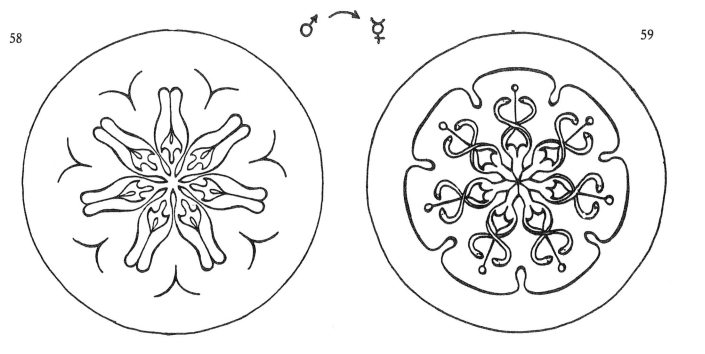

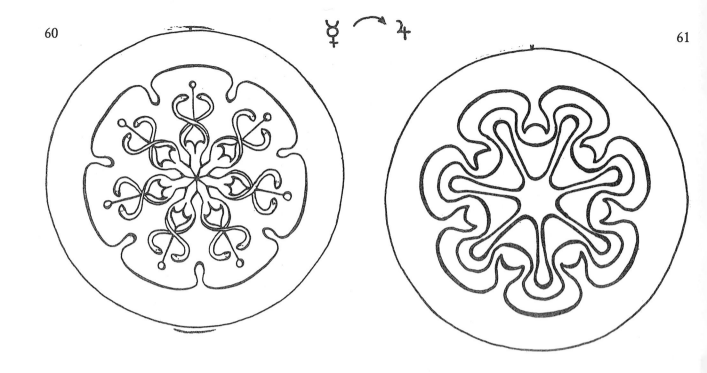

60

61

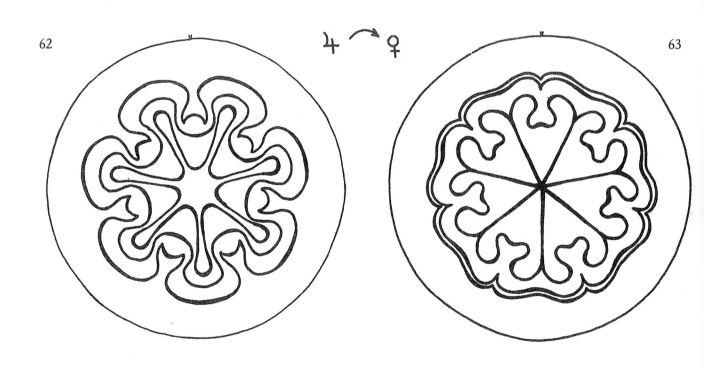

62

63

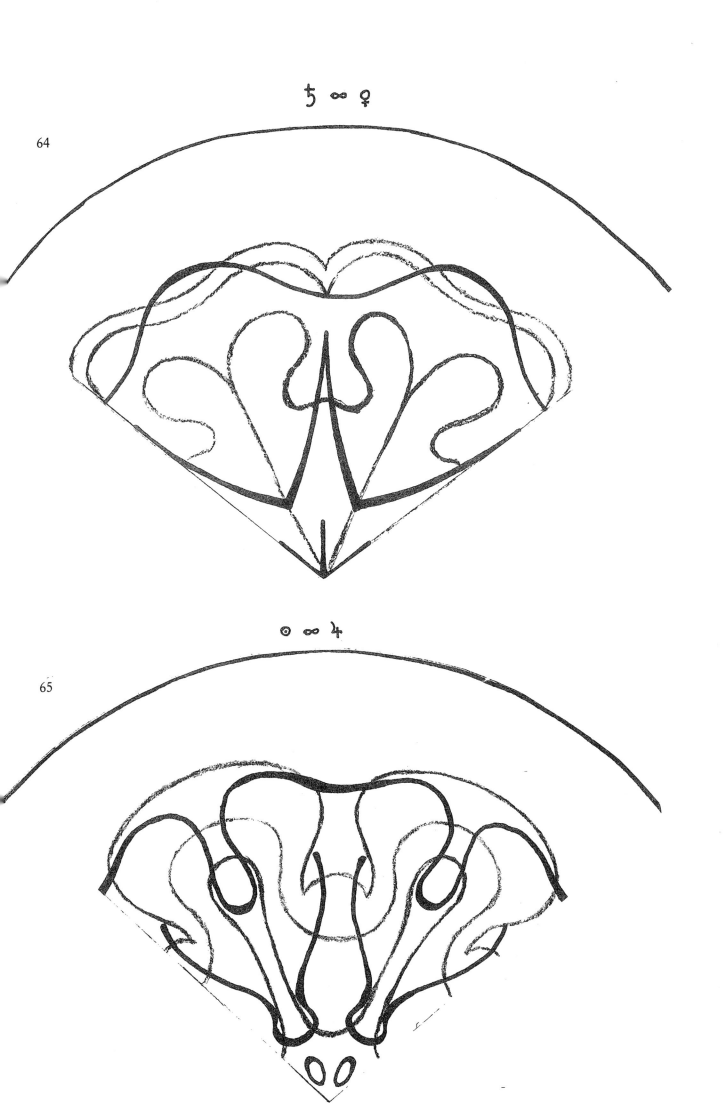

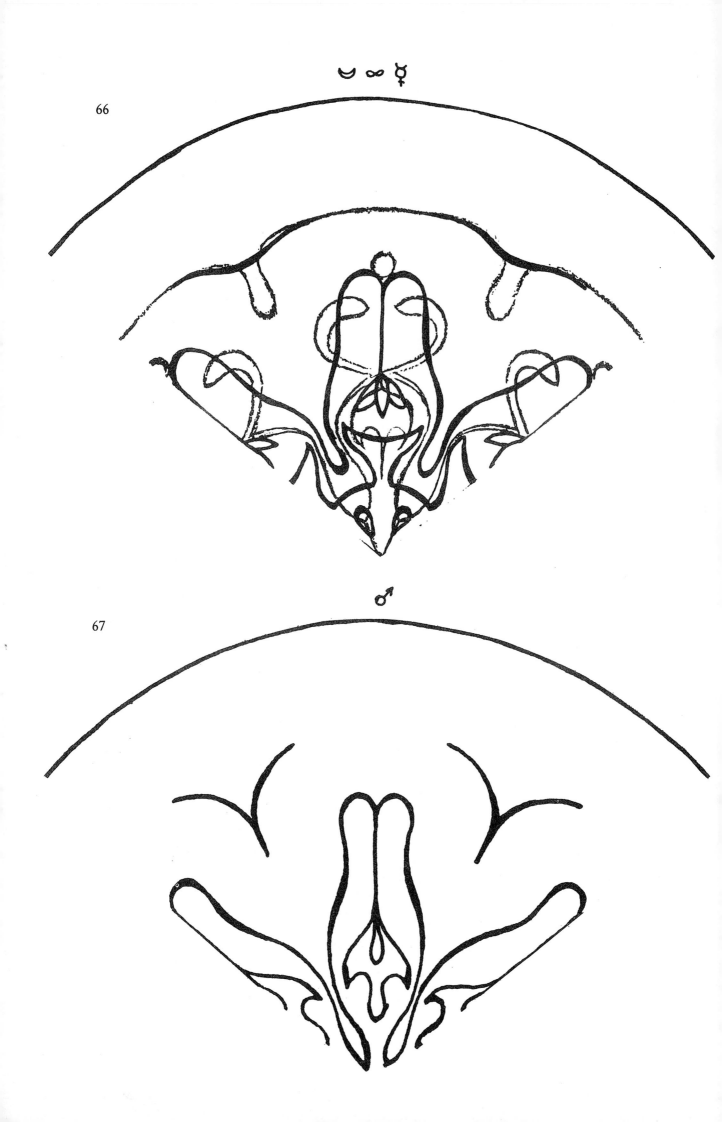

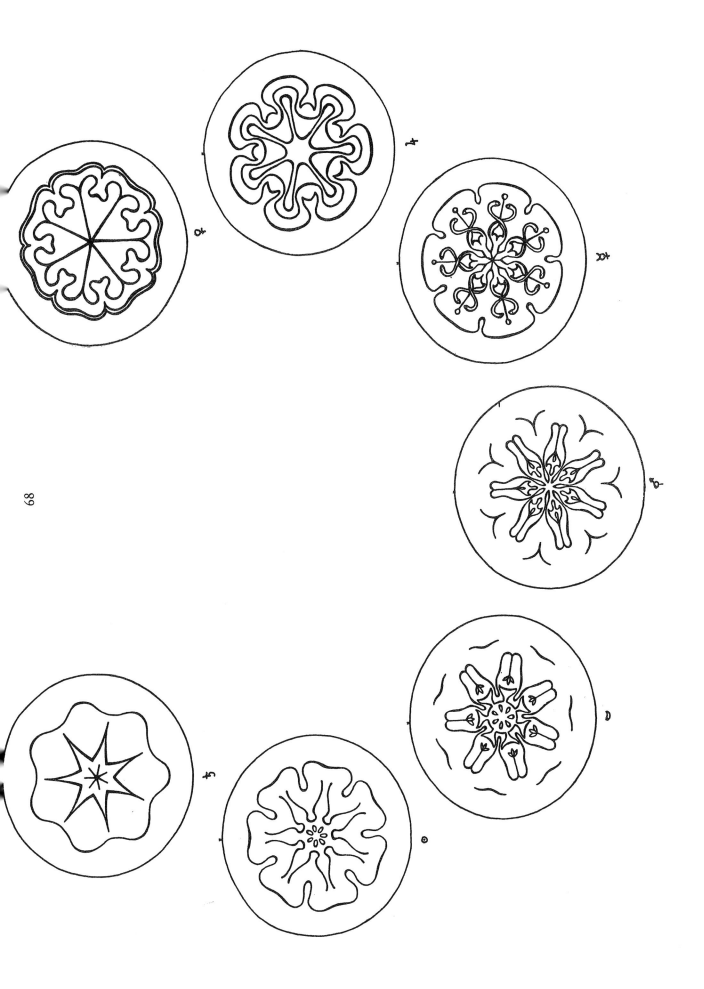

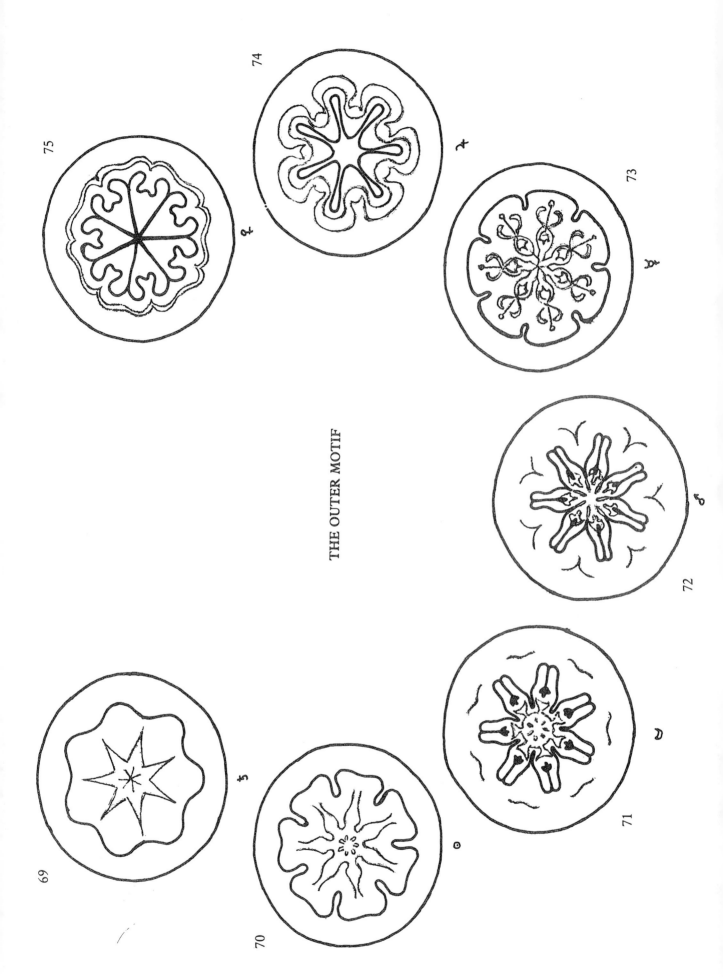

THE OUTER MOTIF

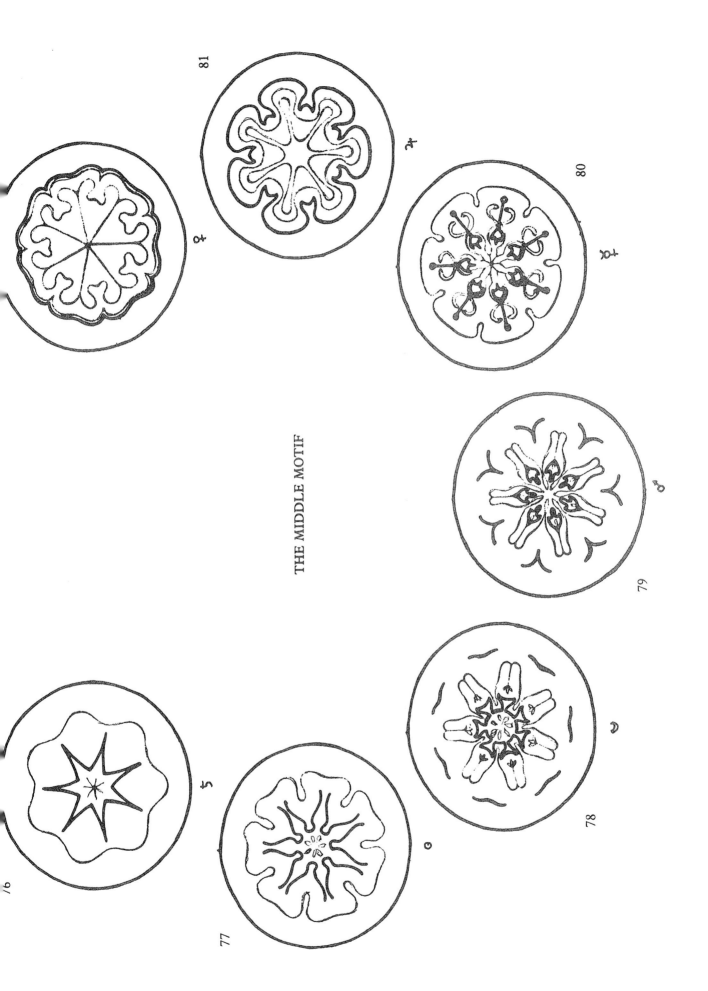

THE MIDDLE MOTIF

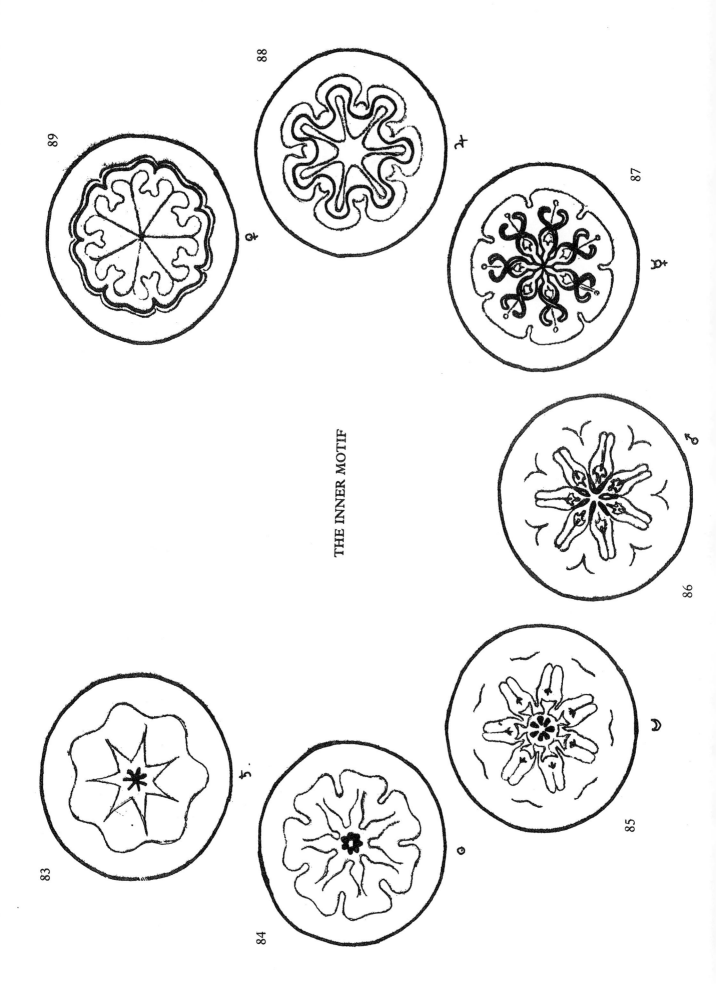

THE INNER MOTIF

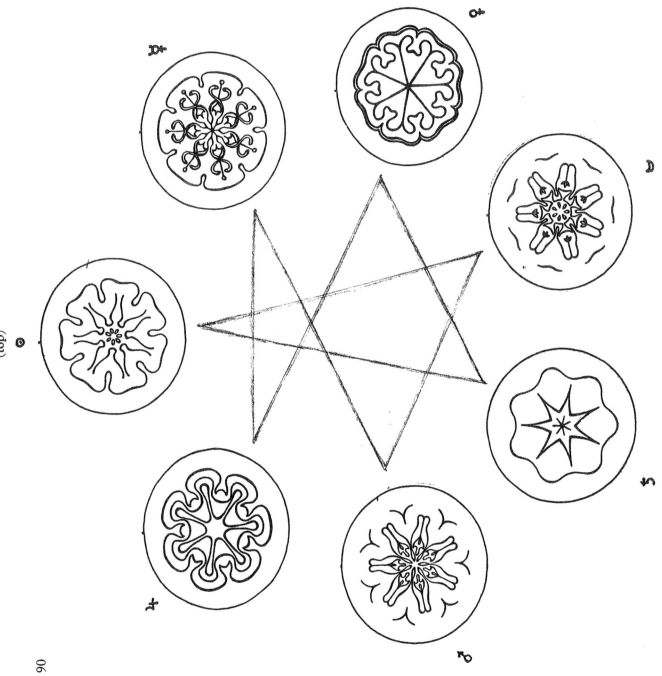

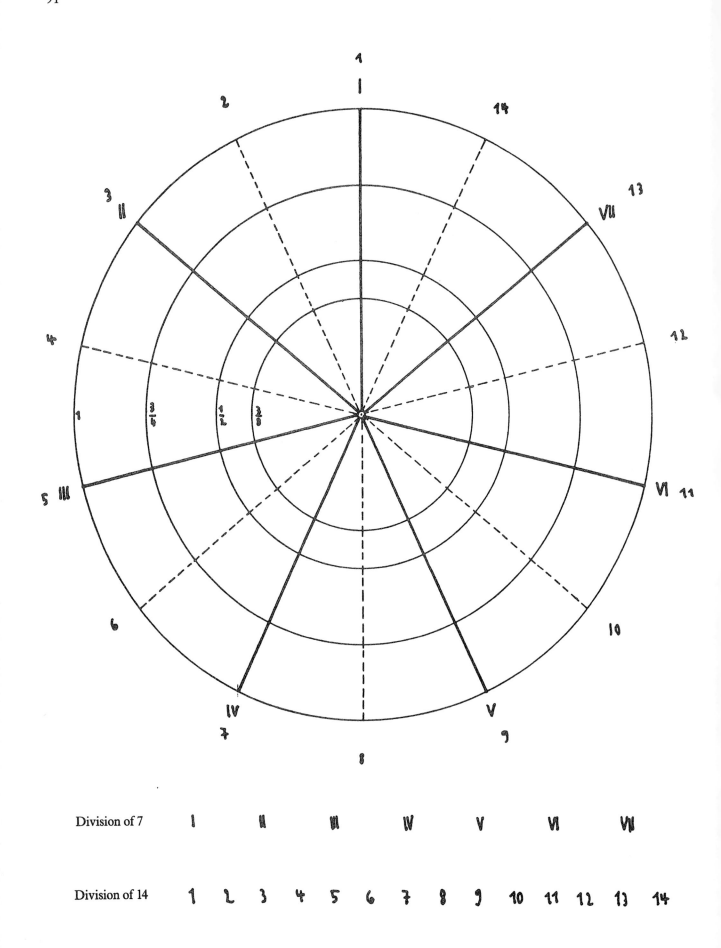

Division of 7    I    II    III    IV    V    VI    VII

Division of 14    1   2   3   4   5   6   7   8   9   10   11   12   13   14

# REFERENCES

## SECTION IX

1. Rudolf Steiner: *Ways to a New Style in Architecture* 28th June, 1914 Dornach. Anthroposophic Press, New York 1927

2. Rudolf Steiner: *Bilder Occulter Siegel und Säulen* Rudolf Steiner Verlag, Dornach 1977

3. Carl Kemper: *Der Bau* Freies Geistesleben, Stuttgart 1966

4. Rudolf Steiner: *Occult Science, an Outline* Rudolf Steiner Press, London 1955, Anthroposophic Press, New York 1972

## SECTION X

1. Rudolf Steiner: *Anthroposophical Leading Thoughts* 105 and 106

2. Rudolf Steiner: *Signs and Symbols of the Christmas Festival,* Berlin 19.12.1904 Anthroposophic Press, New York 1969

## SECTION XI

1. Carl Kemper: *Der Bau,* Freies Geistesleben, Stuttgart, Germany 1966

2. Hans Bornsen: *Das geheime Gesetz des Siebenecks*

3. Rudolf Steiner: *The building at Dornach,* 24.01.1920, Typescript z 9

4. Rudolf Steiner: *Der Baugedanke des Goetheanum,* 16.10.1920, Dornach, Switzerland 1942

5. Rudolf Steiner: *The cosmic prehistoric ages of man,* 21.09.1918, Typescript z 362

6. Rudolf Steiner: *Ways to a new style in architecture,* 17.06.1914, Anthroposophic Press, New York 1927

7. Rudolf Steiner: *A sound outlook for today and a genuine hope for the future*, 03.07.1918, Typescript z 362

(Typescripts are generally available from anthroposophical lending libraries.)

## SECTION XII

1. All rights reserved by Rudolf Steiner Nachlaßverwaltung, Dornach, Switzerland

2. Rudolf Steiner: *Anthroposophical Leading Thoughts*, Rudolf Steiner Press, London 1973

3. Rudolf Steiner: *Knowledge of Higher Worlds*, Anthroposophical Publishing Company, London 1958

4. Rudolf Steiner: *Bilder Okkulter Siegel und Säulen*, Rudolf Steiner Nachlaßverwaltung, Dornach, Switzerland 1977

5. Rudolf Steiner: *The Apocalypse of St John*, Rudolf Steiner Press, London 1977

6. Carl Kemper: *Der Bau*, Freies Geistesleben, Stuttgart, Germany 1974

7. Rudolf Steiner: *Occult Science*, Rudolf Steiner Press, London 1963

8. W. Pelikan: *Sieben Metalle*, Dornach, Switzerland 1952
   L. F. C. Mees: *Lebende Metalle*, Stuttgart, Germany 1977

9. Rudolf Steiner: *Kleinordien-kunst als goetheanistishe Formsprache*, Dornach, Switzerland 1984

# FURTHER READING

Keith Albarn, Jenny Miall Smith, Stanford Steele, Dinah Walker, *The Language of Pattern,* Thames and Hudson.

Anke-Usche Clausen and Martin Riedel, *Zeichnen Sehen Lernen,* F. Ch. Mellinger Verlag, Stuttgart. (This book is almost entirely drawings, therefore an understanding of German is not essential.)

H. S. Crawford, *Irish Carved Ornament,* Mercier Press, Dublin & Cork, Ireland.

Ernst Haeckel, *Art Forms in Nature,* Dover Publications Inc, New York.

Herman Kirchner, *Dynamic Drawing, its therapeutic aspect,* Mercury Press Fellowship Community, Spring Valley, New York.

Rudolf Kützli, *Langobardische Kunst,* Verlag Urachhaus, Stuttgart 1974.

Lindholm-Roggenkamp, *Stave Churches in Norway,* Rudolf Steiner Press, London.

Hans R. Niederhäuser and Margaret Fröhlich, *Form Drawing,* Rudolf Steiner School, New York.

Jill Purce, *The Mystic Spiral,* Thames and Hudson.

Theodor Schwenk, *Sensitive Chaos,* Rudolf Steiner Press, London.

Jacob Streit, *Sun and Cross,* Floris Press, Edinburgh 1984.

*The Book of Kells,* Thames and Hudson.

## Ordering books

If you have difficulties ordering Hawthorn Press books from a bookshop, you can order online at **www.hawthornpress.com** or you can order direct from:

Booksource
50 Cambuslang Road, Glasgow, G32 8NB
Tel: (0845) 370 0063
Fax: (0845) 370 0064
E-mail: orders@booksource.net